CONTENTS

PORTRAIT OF AN ARTIST
JUDY MARTIN

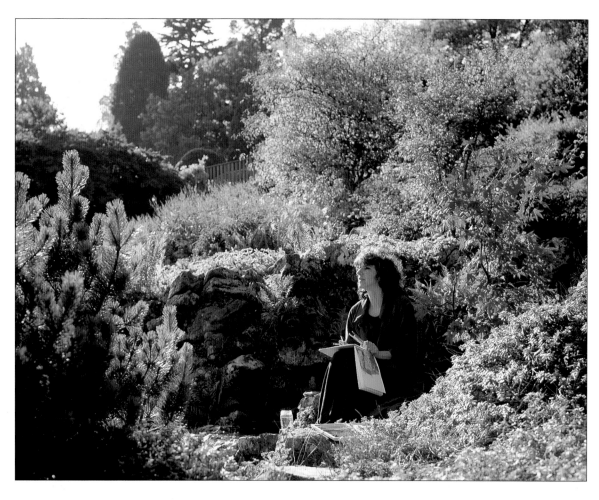

Judy Martin lives and works in Brighton. She trained at Maidstone College of Art and Reading University, specializing in painting and printmaking, and initially worked as a part-time college lecturer. Within a few years of leaving college, she became involved in publishing work and gradually built up a specialist role as a freelance writer and editor of practical art books, at the same time as continuing to paint and exhibit drawings and paintings. Her work as author covers a range of titles, including *Airbrush Painting Techniques, Drawing with Colour, Sketching, Pastels Masterclass* and *Learn to Paint: Colour Mixing.*

A strong interest in the impact of the medium on the look and style of an image is a particular feature of her work as both writer and painter. She has always enjoyed exploring various colour drawing and mixed-media techniques, trying to integrate drawing and painting methods rather than regard them as

▲ *Judy Martin sketching in the ornamental garden near her Brighton home.*

separate disciplines. As a part of this approach, she feels it is essential to acknowledge the special properties of any individual medium, and to allow its characteristic marks and colour qualities a definitive role in image-making. This provides an important common thread between the projects she creates for her books, which investigate the technical and visual interpretations of particular subjects, and the more broadly expressive, abstract style of her studio work.

▲ Garden Arch
17.5 × 21 cm (7 × 8¼ in)

WHAT ARE
WATERCOLOUR PENCILS?

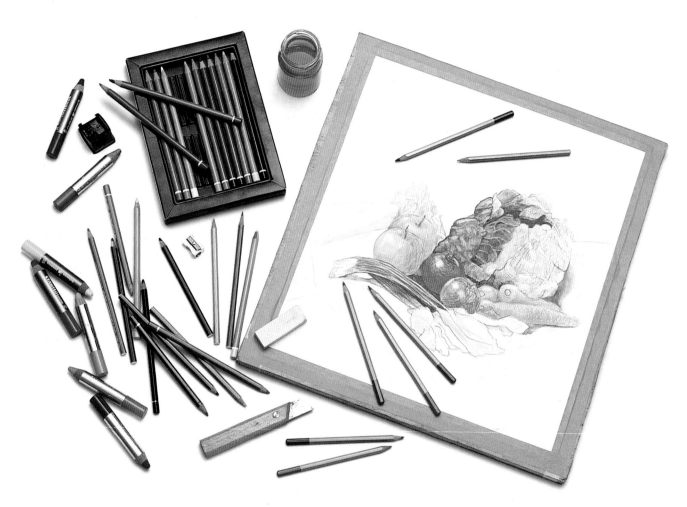

Superficially, a coloured pencil that is water soluble looks no different from one that is not. All types are conventionally made, with the coloured 'lead' – or strip – encased in wood, with one end sharpened to a point. The strip can be fine and hard or soft, waxy and giving, and in ordinary drawing pencils it is formulated to produce non-soluble, permanent marks. In watercolour, water-soluble or aquarelle pencils, as they are variously known, the strip itself,

or marks made with it, softens and dissolves on contact with water and the medium can be spread with a brush like paint.

TEXTURE AND COLOUR

There are several ranges of watercolour pencils available. In most of the major brands, the strip is firm-textured but giving on the paper, slightly waxy when used dry for soft line and shading, but brushing out easily into

▲ *There are slight variations between different brands of watercolour pencils in the texture and handling qualities of the colour strip. You can combine these and, by building up a mixed stock of pencils, you can also extend the range of your colour 'palette'.*

diluted washes. There is also a harder, more brittle type of pencil that makes longer, finer points, and another with very soft, broad, crayon-like strips.

Colour ranges vary from 40 in total to 120 in some brands. The pencils are usually sold in boxed sets and as individual colours. It is often easiest to begin with a small colour set and then add single pencils as you see which extra colours your work requires. However, a larger set can be an advantage in range and economy.

Ways of identifying colours vary from brand to brand. Most have reference numbers rather than colour names. Named colours may refer to pigments used in standard watercolour paint ranges, such as ultramarine, or they may be descriptive, such as kingfisher blue. For practical purposes, it is easiest to think of the kind of colour you want when choosing or adding to your stock – a bright orange-red or a deep crimson; a deep blue-mauve or a rich magenta. Buying pencils individually also allows you to mix and match between ranges, though keep in mind that the textures may differ. Fortunately, pencils are usually displayed in a way that enables you to inspect the strip. This is the most concentrated form of the colour; remember you will get paler and more subtle shadings as you dissolve and brush it out.

WATER-SOLUBLE GRAPHITE

These are the water-soluble equivalent of ordinary 'lead' pencils, with similar silvery-grey or blackish tones. You can use them for line work or brush them out into washes, as with the coloured pencils, and the two media combine well. There is not such an extensive choice of hardness or softness as in the H and B ranges of non-soluble graphite; you will usually find about three different grades.

▼ *Water-soluble graphite pencils typically provide three grades of softness, or 'blackness', in the wash. From left to right, this picture shows two pencil types with gradings described as light wash; medium (softness); medium wash; soft; dark wash; very soft.*

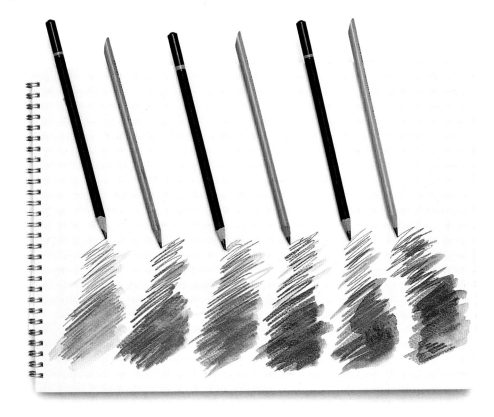

STYLE AND TECHNIQUE

It is important to regard watercolour pencils as a medium in their own right, and not simply equivalent to watercolour paint in stick form. The ingredients of the strip, which include pigments, binding material and wax, make the dissolved colour more opaque and slightly chalkier than pure watercolours. True watercolour technique depends partly on the white paper beneath the transparent colours adding to their vibrancy. The watercolour pencil colour has a degree of transparency when thinned to a wash, but the colours do not have the same depth and 'glow' as paint.

The main thing that restricts your ability to 'paint' freely with the soluble pencils is the actual amount of colour that you can get from the strip. You have only a limited capacity for pre-mixing as compared with the quantity and subtlety of mixtures you can obtain with watercolour paint. Usually with pencils, you make blends and mixtures directly on the paper, and you have to take care that they do not flatten and become muddy. But once you get used to manipulating the pencils dry and wet, you will find ways of layering and texturing the colour that give plenty of creative scope.

SKETCHING MEDIUM

Soluble pencils can, however, act as a convenient alternative for watercolour if you are sketching away from home. They are clean and easily portable, you do not need as much water and you do not have to take a palette. The colour picked up on the brush is much less than with paint, so the water that you use to dilute washes and rinse your brushes does not colour up as heavily or as quickly.

This kind of practical advantage can compensate for whatever you might lose in terms of colour range, especially if you are making reference sketches rather than trying to develop finished drawings.

Another technical advantage of using pencils is that many people feel more comfortable working with a drawing tool than with a brush when they begin to work in colour, because this is how they have learned to draw and acquire the skills of translating the three-dimensional world into pictures. It can be daunting to start directly in paint because the material seems too free and uncontrollable.

Pencils allow you to define a drawing quite tightly to begin

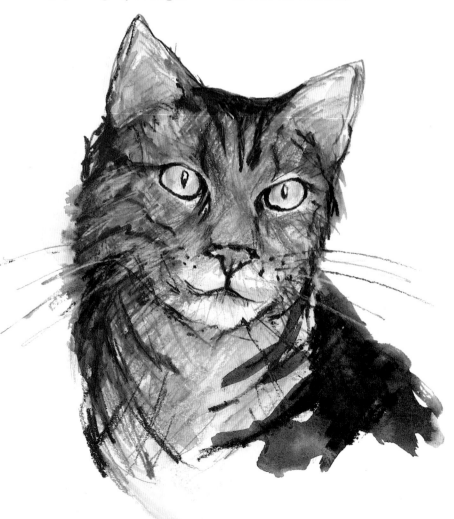

▼ The Raggy Tabby
20 × 20 cm (8 × 8 in)

8

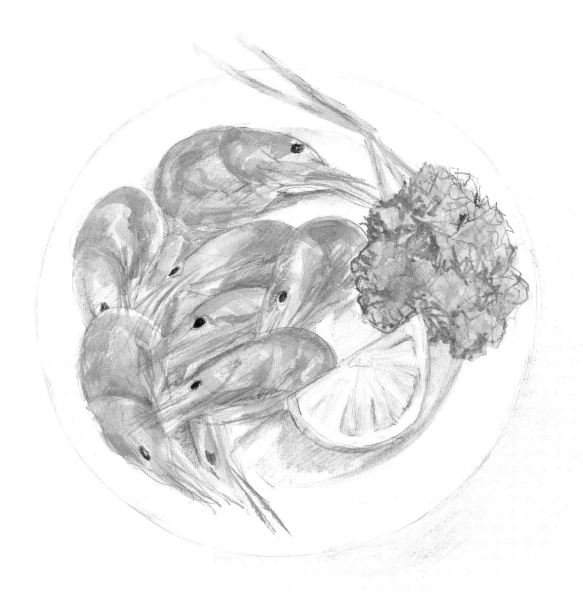

with, then gradually free it up with washes if you wish. You can also rework with dry pencil over the washed effects, so the layers can become quite complex and rich. The combined qualities of wet and dry marks supply the kind of delicate surface colour and blending that is appealing in certain types of watercolour pictures, but also grainy textures and linear detail not easily achieved with a medium that is always wet.

As with most drawing and painting media, there is no specific right or wrong way to use watercolour pencils. You need to explore their qualities and learn to play to their strengths. There is also the question of what you are trying to do with them, and finding out how particular techniques and ways of developing a drawing can help you achieve the result you want. The purpose of this book is to look at watercolour pencils broadly in those terms and offer ideas that can be adapted to your own choice of subject and style.

▲ Plate of Shrimps
22 × 21 cm (8½ × 8¼ in)

BRUSHES AND PAPERS

As a general rule, you need soft hair, not bristle brushes for wetting and brushing out watercolour pencil marks. The texture should be flexible and springy, and the brush should return readily to its original shape without splaying or shedding. Synthetic-hair brushes are best. Although sometimes your technique will consist of stroking lightly with the brush, you also need to be able to push the colour around on the surface vigorously. Animal hair brushes feel too soft and can be spoiled by such treatment. For both economy and resilience, the synthetic brushes (or synthetic/natural blends) made for watercolour or acrylic painting suit this medium well.

BRUSH SHAPES

Many people prefer round-hair brushes – the classic paintbrush shape – because they are both familiar and versatile. The point

▼ *The brush sizes you need depend on the scale and detail of your work. This versatile selection includes (left to right) a large, flat wash brush; medium-sized round-hair brush; medium-sized flat; large round; small round.*

negotiates outlines and fine detail, and the broader swell of a medium or large round brush spreads colour washes easily. However, flat brushes are very useful for painting up to straight edges or into irregular outlines, 'banding' blended colours smoothly, and for texturing pencil shading roughly when the brush is just moist. A reasonably versatile basic set to start with is a small round brush for detail, a medium-sized round or flat for general purposes, and a larger size for broad washes.

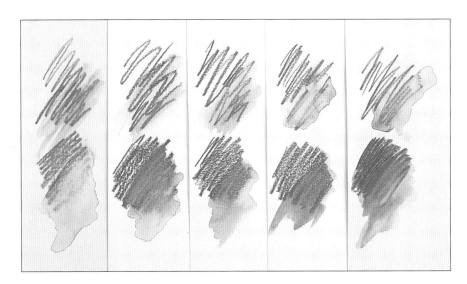

PAPERS

All types of drawing and watercolour papers are suited to this medium, but avoid thin papers that pucker and buckle irretrievably when wet. If your technique includes a lot of wetting out, stretch the paper first. Stretched paper always dries out flat, no matter how much it has buckled as you work.

The texture of your working surface has a considerable effect on the way marks and colours appear, and on the overall impression of the finished picture. Smooth papers create a kind of delicacy, because the colour lies on top. Heavyweight cartridge paper and thin Bristol board come into this category. However, a smooth surface can break down if you work on it with the pencil tips while it is damp.

Watercolour papers are firm and durable and are available in a wide range of weights, surface qualities and thicknesses. A rough, grainy paper contributes interesting texture to a drawing. Lighter-grained types are receptive to more sensitive marks and colour effects, but the

'tooth' of the paper grain helps to grip the colour when you want to build up the colour intensity. Good-quality watercolour papers are tough and should stand up to erasures and overworking.

With papers categorized by weight, 90lb (190gsm) or more should not need stretching unless you intend to work very wet. For the drawings in this book, mainly heavyweight cartridge and 90lb (190gsm) or 140lb (300gsm) Bockingford papers were used, all sold by Daler-Rowney in pads of varying sizes.

OTHER EQUIPMENT

The beauty of this medium is that the only essentials are your pencils, brush and paper, a pencil sharpener or knife, and a jar of water. A plastic eraser is invaluable, but use it only on colour that has dried, since it will tear damp paper fibres. Tissues or paper towels are often needed for blotting brushes or over-wetted paper. To attach the paper to a drawing board, use low-tack masking tape, or gummed paper tape for stretching.

▲ *The main variations in papers are thickness (weight) and surface texture (grain). The purity of the whiteness also varies between types. These swatches show the effect of watercolour pencil hatching, shading and wash on (left to right): Bristol board; 140lb (300gsm) Bockingford watercolour paper; 90lb (190gsm) Bockingford; 72lb (150gsm) Bockingford; double-weight cartridge paper.*

Tip

● To stretch paper, soak the sheet in clean water and then lay it flat on your drawing board. Tape down each side with a strip of brown gummed paper tape, making sure to keep the edges smooth. Let it dry out completely before you start work.

MAKING MARKS

The types of marks you can make with watercolour pencils range from sharp, hard pencil lines and grainy masses of dry shading to subtly blurred blends and fully dissolved colour washes. There are also several ways to combine these dry and wet effects in order to vary colour quality, so the medium's versatility is considerable.

BRUSHING OUT COLOUR

A basic technique used in this medium is converting dry pencil shading into a watercolour wash simply by lightly brushing over it with clean water. If you shade finely and closely, the colour will dissolve completely and the wash effect is then smooth and even. A more vigorous, scribbled style of shading means that the directional pencil marks may remain visible in the wash.

The amount of water affects the colour quality. With a moist brush, you can create an even wash. If the brush is wet, the

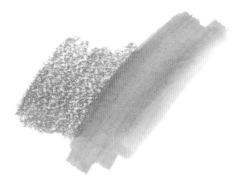

▲ *Light shading, brushed out into washed colour.*

▲ *Heavy shading, brushed out into washed colour.*

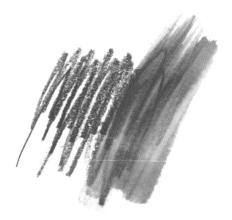

▲ *The effects of washing out loose (above left) and coarse (above right) hatched marks. Note that the pencil strokes remain visible.*

▼ *Washes made by dampening shaded colour with a moist brush (below left) and a wet brush (below right). Wetting tends to push the colour to the edges of the wash.*

Tip

● Applying water to dry colour marks tends to spread them out, and overwetting reduces colour intensity. To keep washes under control, moisten the pencil shading gradually and brush the colour evenly to the edges of the shaded area.

wash tends to 'puddle', with stronger colour showing around the edges. If you blot the brush, however, so that it is merely damp, you can retain some of the textural quality of the grainy pencil lines within the translucent brushed colour.

Colours are easily blended by laying down bands of shading and brushing them together. Open shading, such as scribbling and crosshatching, can also be used to vary textures and colour combinations.

Layered washes are a way of building up the intensity of tones and colours. Wait until the first washed layer is dry before shading over the top, and don't add too much water or you may 'pick up' the underlayer.

WET DRAWING

A wetted pencil tip makes a very strong mark. Water softens the colour strip so that it smears on to the paper in a heavy trail. The crispness of the mark depends on how sharp the pencil is before you moisten it, but it wears down quite quickly.

If you start shading with a wetted pencil, the moisture soon runs out and the colour starts to look grainy once more. Either exploit this variation, or smooth out the grain by moistening the pencil tip again.

The wet marks are intense and it is difficult to soften or erase them if you have made an error. But this is the most direct way to obtain accents of really bright or thick colour. You can create an impasto texture – in which the pencil marks are evident – by rolling and increasing pressure on the pencil, wetting the tip each time it dries out.

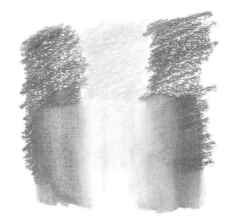

◀ *The effects of blending colour bands, using a flat, moist brush travelling vertically.*

▲ *Textured washes made by brushing over fine and coarse crosshatching.*

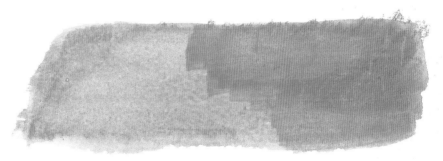

▲ *The effect of applying a second wash (above right) over one that has dried, to intensify the hue.*

▲ *The marks of a sharp, wetted watercolour pencil tip, alternating with the grainy lines created as the moisture runs out.*

▲ *An impasto texture created by shading and rolling the wetted pencil tip.*

13

▲ *Dry pencil applied into clean water (top) and a damp colour wash (above). The marks naturally spread and become fuzzy.*

DRY INTO WET

Drawing or shading directly into a wet surface – either a colour-washed one or one wetted with clean water – enables you to produce a range of variegated colours and loose textures. The strokes are softened by the moisture, so any type of drawn mark is less sharp than it would be if applied to a dry surface. Your marks can end up looking just vague and fuzzy, so you need to match the techniques to a suitable aspect of your subject.

Another factor to bear in mind is that the pressure of the pencil tip may damage the damp paper you are working on. To avoid this, use a blunt pencil or turn the point on its side. Do not press too hard and stop work if the paper surface begins to break up. Let the paper dry out thoroughly before adding any more colour.

DRY OVER DRY

Applying pencil drawing over a dried wash allows you to develop a variety of textures and to build up increasingly subtle integrated colour layers. Shade closely for a strong colour effect, or use more open marks to let the underlayer show through to the surface.

Whereas a wash that has dried may remain stable when another is applied on top, dry colour always retains the potential to dissolve, so dry drawing over previously applied colour tends to be a finishing stage or a way of increasing colour intensity.

A heavily worked surface will eventually become resistant to further colour as the pencil point begins to compress and 'polish' the waxy pigment. This is good for final colour accents, but it has obvious disadvantages for the early drawing stages. If you have overworked too heavily too soon, dampen the colour and try to lift it with a blotted brush. Wait until the paper dries out again before reworking.

▲ *Dry shading over a dry wash with the same colour (top) and a second colour (above).*

BRUSH TECHNIQUES

Apart from converting pencil marks to a wash on paper, you can also apply colour directly with the brush. For tiny details, you can pick up the colour on the moist brush from the pencil tip. Another way of working is to scrape colour from the pencil strip into a palette or dish, but it is easier to shade it down on to a spare scrap of paper, moisten it and brush it up from there. This is like making temporary paint 'pans' – the little blocks of colour in a watercolour box. Use this method to provide single colours as you need them, or to mix colours in advance.

▲ *Direct brush strokes with a round-hair brush (above left) and a flat brush (above right).*

◀ *Dry-brush texture made by blotting the brush and splaying the hairs between finger and thumb.*

LIFTING AND ERASING

Lifting colour can be a corrective measure – when the wetted colour has spread too far or is too intense – or a positive technique for putting tone and texture into washes. You can pick up damp colour on a barely moist or dry brush, a tissue or a sponge, but if the wash has already dried you will first have to wet it again with clean water before trying to lift out most of the colour. Be careful not to scrub at the surface of the paper, since it will be impossible to rework it smoothly if the paper fibres have been damaged.

An eraser will take out direct pencil marks and dried washed colour. If you have pressed hard, or have used a strong colour that has stained the paper, you may not be able to get rid of marks completely. But you can often clean up the surface sufficiently to rework it. For delicate highlighting, cut a slice off the eraser and use the corner to rub into the colour.

▲ *Overlaid colours produced by using separate strokes of a flat brush.*

▲ *Colour lifted out of pencil shading and dried wash using an eraser*

(above left), and out of a wet wash using a blotted brush (above right).

COLOURS

The various name-brands of watercolour pencils provide a wide and generous colour range. It is easiest to work as directly as possible with the pencils, but you will no doubt want to experiment with different ways of blending and mixing colours. However many colours you have, you will often come across something in your subject for which you have no direct equivalent. Mixing techniques are not only useful in achieving a close match for individual colours, they also help to create subtle variations and a richness in the surface layers of a drawing. These aspects enhance qualities of shape, form and texture, making the picture work better as a whole.

The basic ways of combining colours on the paper are to shade or brush together two or more colours, or to work one over another in layers – wet or dry. When you are working with wash techniques, you can also make a little colour palette in order to pre-mix hues off the paper, as described on page 15.

COLOUR COMBINATIONS

You can combine different shades of one colour to produce another – two types of blue or red, for example. Ultramarine may be too cool and deep-toned for the effect you need; sky blue or turquoise too bright. Vermilion may be a little too orange when you need a

really singing red, while crimson is too much on the pink side.

The colour wheel on page 17 shows basic colour relationships that help you to judge how a mix will work. It consists of the three primary colours – red, yellow and blue – and the three secondary colours that represent mixtures

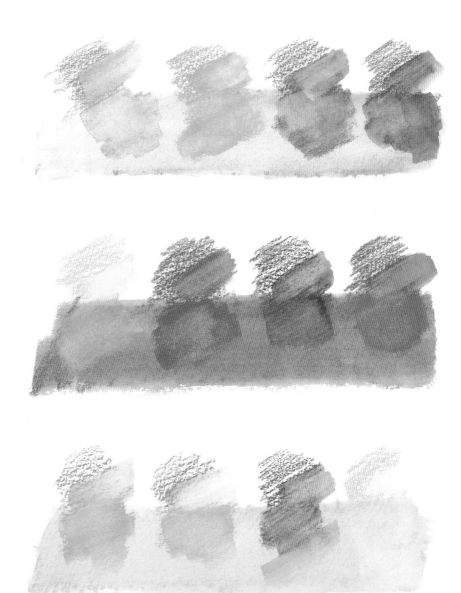

▲ *A wash of one colour over another produces a modified blend rather than a straight mix.*

16

of primary pairs – orange, green and purple. From the progression of adjacent hues around the wheel you can select colours that blend cleanly and harmoniously. For example, if you have one each of red, yellow and orange, you can then produce a variety of shades within that range; likewise with blue/green/yellow and red/blue/purple.

With colours placed opposite each other on the wheel – red and green, blue and orange, or yellow and purple – the mixed colour is quite different from either of its components. These pairs are called complementary colours, and they have a neutralizing effect on each other, producing brownish mixes. This is the reason why paint colours often become muddy on the palette. With care, however, you

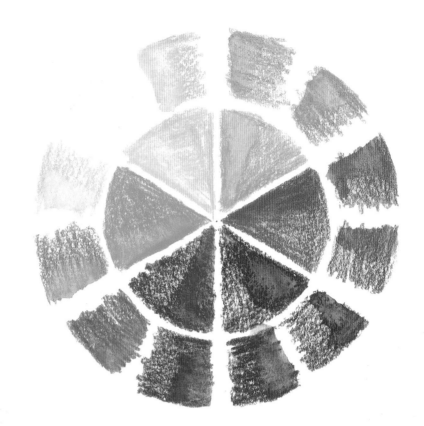

▲ *The colour wheel demonstrates colour relationships based on the three primary colours – red, yellow and blue – and the three secondaries – orange, green and purple. Some of the variations on the basic hues available in watercolour pencil ranges are represented in the outer circle.*

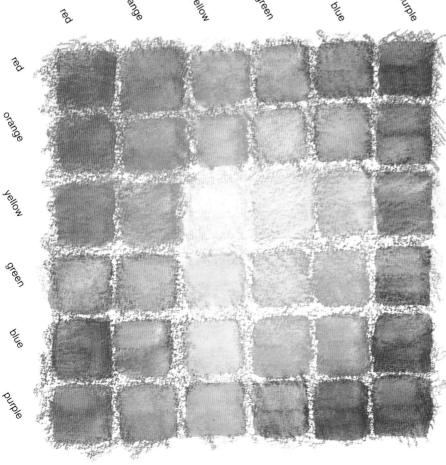

◄ *This block shows mixtures of primary and secondary colours (using six pencils) shaded directly on to the paper and then brushed out.*

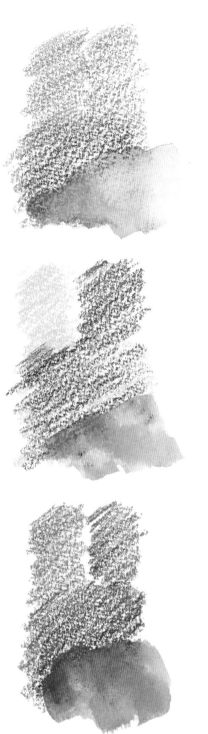

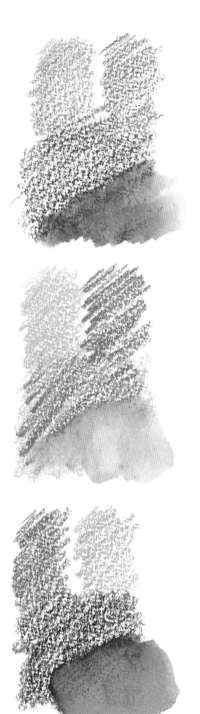

◄ *Combining colours from opposite sides of the colour wheel produces a range of neutral brownish mixes.*

▲ *Very dark, neutralized colours can be achieved by mixing dissimilar colours in deep shades.*

▲ *Black is always very dense, as well as being rather harsh and dull for mixing; warm and cool greys make useful shading colours.*

can use this principle to produce bright reddish or orangy browns, attractive neutral grey-browns and dark-toned shades.

Earth colours – browns and deep yellows – are useful mixers for knocking back the intensity of vibrant, pure hues. Dark-toned colours, such as brown, grey or black, can be used as 'shading' colours, but black is completely neutral and is often too dull to use. Dark greys are good, and there are subtle variations of 'warm' (yellowish or reddish), 'cool' (blue-grey) and mid-toned neutral greys. You can also work with a deep hue that shades more colourfully, such as violet or ultramarine.

MANAGING COLOUR COMBINATIONS

The more you wet a colour wash, the more colour comes up on the brush. Washes also lighten as they dry. If you are layering colours, a wet overlay can dissolve the colour beneath. So achieving the right colour intensity and gradation of mixes takes time and you need to build up slowly to avoid 'puddling'.

If you have a limited number of colours, try making colour charts and samples to find out the variation possible using the different mixing techniques. This not only shows you your options with the colours you have, it also helps you to decide how your 'palette' should be extended. For example, from a colour set with bright reds but no crimson, your deep red or red-purple mixes are unsatisfactory because orangy reds turn brownish when darkened.

Some pencil colours are very bright – almost garish – and a limited stock is restrictive. If you have only a few bright, artificial-looking greens, for example, you can vary the hue by adding yellow or blue, or produce more subdued shades by mixing in a little red, purple or brown. But if you intend to do a lot of landscape work or plant studies, it is handier to build up a broad range of green pencils, including yellow-green and olive shades. The same might apply to your range of blues, yellows or reds, depending on your subject choices and how varied you expect your overall palette to be.

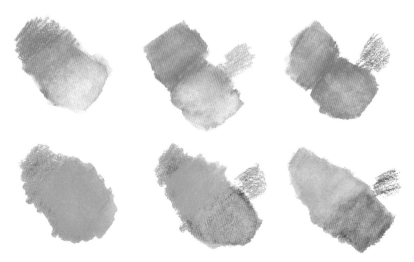

▲ *Using an unlike colour to tone down the intensity of a vivid green or blue creates a more natural-looking hue.*

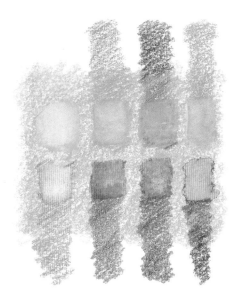

◀ *The effects of mixing related and opposite colours with a particular shade.*

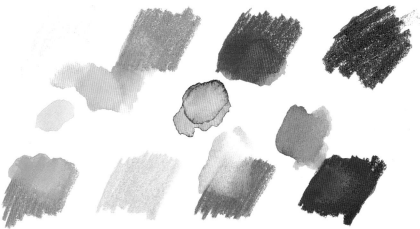

▲ *A paper 'palette' of shaded colour blocks.*

TONE AND COLOUR

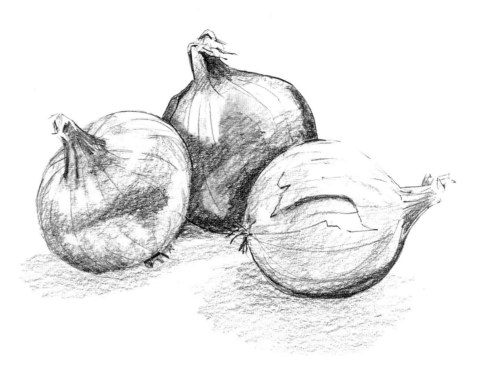

The tonal pattern of a subject is similar to the effect you would see if you took a black and white photograph of it. Tones – the degrees of lightness and darkness – are important in structuring a picture to create depth and solidity. The pattern of light and shadow co-exists with local colours – the surface colours of things – and modifies them.

When working in colour, some artists develop a tonal structure almost instinctively, while others use it as a key component in planning colour effects. Often when a drawing or painting makes the subject look flat, it is the tonal key that is at fault, rather than the colour range. But the two elements interact so closely that it can be difficult to analyse how the combination works.

Most people learn to draw tonally, in a medium such as pencil or charcoal. If this applies to you, use that skill to help develop your confidence in drawing with colour, either by progressing from tonal to colour interpretation, or by integrating the two.

USING WATER-SOLUBLE GRAPHITE

Technically, water-soluble graphite pencils are a useful intermediary. You can use them as if they were ordinary pencils in line and shading, and then experiment with brushing them out into washes to find out how the tonal range varies when used dry or wet, and how you can build up shape and texture with different kinds of marks. This can be translated into colour using the same sort of processes employed in your tonal drawings, or your coloured pencil work can be combined with the graphite tones, because the media are natural partners.

TECHNIQUE AND STYLE

It is best to begin with a simple subject consisting of basic shapes, such as the onions and eggs used in the exercises on these pages. When you are trying out techniques, the subject of your drawing does not really matter, but look for something that enables you to narrow the focus of what you are trying to do, rather than juggling many different elements at once.

The onion drawings show a complete transition from tone to colour, and the intention is to make the shapes look quite firm and rounded. The basic tonal pattern consists of gradations of light and shade showing how the shapes curve towards or away from the source of light. There are also cast shadows that describe the position of the onions, both in relation to each other and to the surface on which they are sitting. In each of the drawings I have used the qualities of the particular medium to help to define that overall pattern of tones.

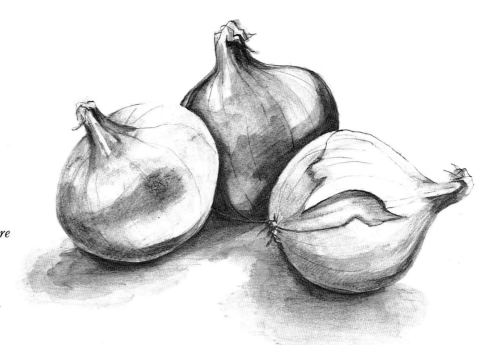

◄ *Working in dry graphite pencil creates a typical type of grainy texture in this drawing of onions.*

► *This version in water-soluble graphite pencil has a more delicate, smoothly gradated effect where the tonal shading is converted to wash.*

◄ *The tonal balance here is made by colour shading, using purple, brown or grey-blue, overlaid at first with washes of red and yellow, then more fully blended with the surface colours. The final touches of detail on the onion skins were made with dry pencil drawing over dried washes.*

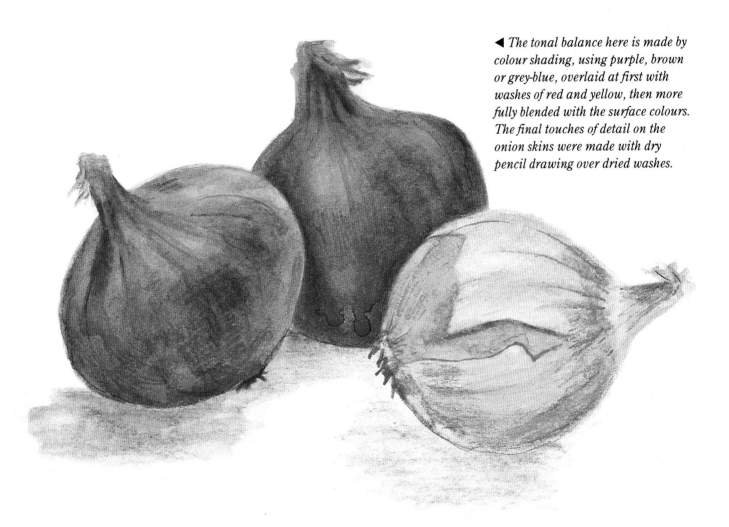

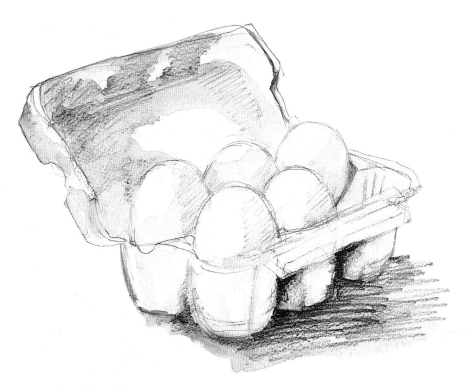

◀ *The light and mid-tones were made by brushing out the pencil marks loosely, allowing some of the linear, grainy texture to remain. The darker tones on the underside of the box came from shading into a still-damp wash, which picked up the graphite more strongly.*

MIXED TECHNIQUE

In the egg box drawing, I have combined the coloured pencils and water-soluble graphite directly. This is an interesting technique in itself, one that you can adapt for other subjects. The soft, translucent quality of the brushed-out graphite blends well with the textures of washed and dry-shaded colours.

I purposely chose a subject with a restricted colour range to make it easier to identify tone and colour as individual elements. I treated them separately at first, using the graphite pencils to sketch outlines and apply loosely hatched shading, which I then washed over with clean water. The basic visual pattern is the same as that used for the onions – tonal modelling around the shapes and cast shadows locating the objects in space. The different appearance of the drawing is due to the freer style.

I applied the colour delicately at first and then built up the image more boldly. It was not a matter of just 'colouring up' a tonal drawing, although that is the general principle of the combined technique. But I found it more effective to pull together tones and colours gradually in the final stages by moving back and forth between the two media.

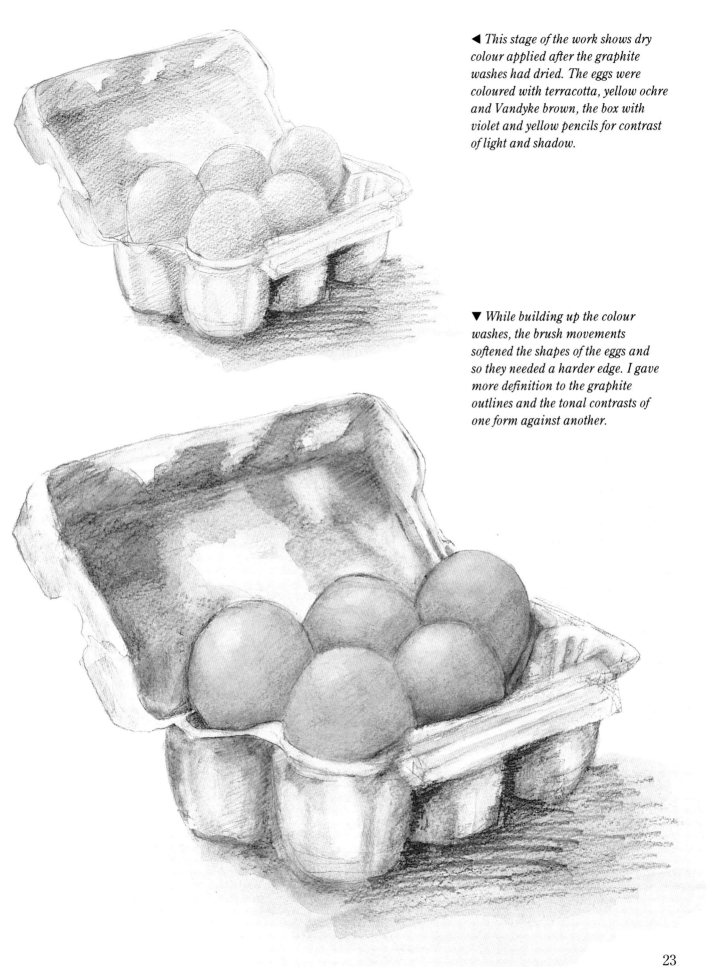

◄ *This stage of the work shows dry colour applied after the graphite washes had dried. The eggs were coloured with terracotta, yellow ochre and Vandyke brown, the box with violet and yellow pencils for contrast of light and shadow.*

▼ *While building up the colour washes, the brush movements softened the shapes of the eggs and so they needed a harder edge. I gave more definition to the graphite outlines and the tonal contrasts of one form against another.*

STILL LIFE

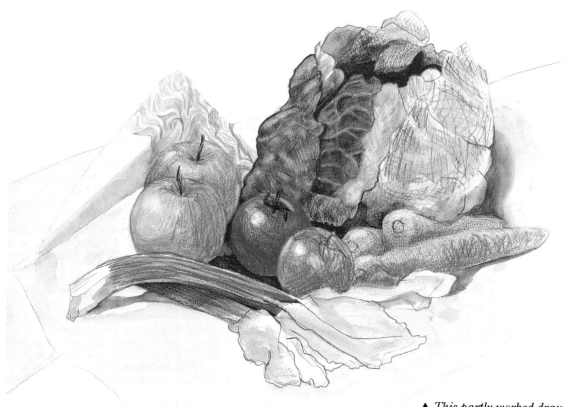

▲ *This partly worked drawing helps you to see the structure of the mark making.*

A still-life picture of fruit and vegetables is a good subject for testing what you can do with watercolour pencils. As well as having a manageable scale, you can choose simple or complex shapes, colours and textures and also try out different techniques. You could regard this as the next step from making marks (see pages 12-15), exploring how to combine them to build a picture.

Try working loosely at first, and gradually pull the shapes and details together. You can use an eraser on line, shading and dried wash if you need to, or make adjustments by overworking as you go along. The example here

is left unfinished to show how sketchily the colour is laid in at first. In the more finished parts, you can see that some of the techniques are still quite rough and free, but also how the colour layering develops the solid shapes and surface variations.

MODELLING AND TEXTURE

Highlighting is important for modelling simple, smooth forms like the tomatoes and carrots, and for creating textures such as the crinkly cabbage leaves. To ensure pure, white highlights, it may be best to leave the base

paper showing through, but you can retrieve pale tones by erasing or wetting the colour and lifting it with a just-moist brush (see page 15). Using a white pencil for highlighting works best if you apply it dry, after the washed colours have dried, or it will pick up the underlying tint.

You have choices all along the line as to the degree of finish you want. Think about how much detail and colour intensity you want to show, and how the tonal range is working to emphasize shapes. Keep checking the overall effect as the drawing proceeds so that you can gradually integrate the various elements.

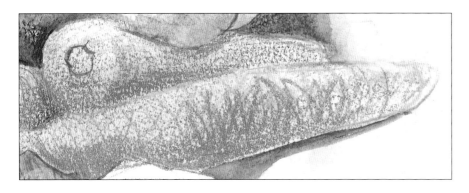

◀ *Note how loose hatching around the shape helps to suggest form and texture, while the wash of blue-grey cast shadow underneath adds depth.*

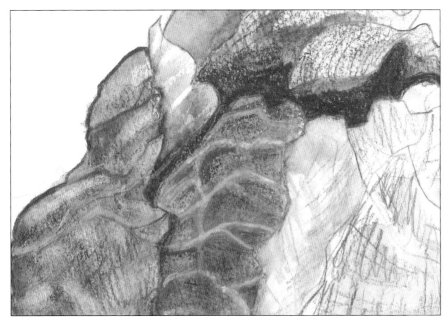

◀ *Dark-toned dry shading over a colour wash leaves the pale veins standing out on the purple leaf. On the outer green leaf, the highlights were lifted out with a plastic eraser and the veins were drawn in red.*

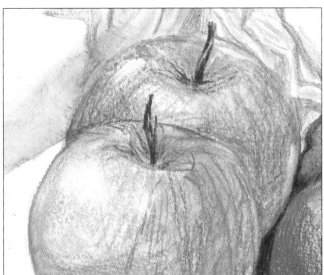

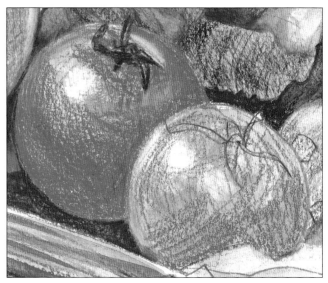

▲ *The greens were built up dry/wet/dry, with red lines showing the detail of local colour on the apple skin.*

▲ *Washes of bright red, overlaid by dry shading in red and yellow, were used to intensify the colours and harden the outlines, with dark brown shading applied to 'curve' the shapes.*

FLOWERS

Flowers are always a popular and appealing subject, and with watercolour pencils you can vary your approach considerably in order to bring out the qualities of the subject that particularly interest you.

A controlled technique of line drawing, shading and blending with a brush is a suitable approach to individual studies focusing on precise shapes and colours. If your subject is a mass of flowers, you can try a freer, more impressionistic style.

SHAPE

In choosing to draw the spray of nasturtiums, I was interested in both the vivid colours and the

▼ *Dry shading brushed over with water created the basic petal shapes in clear colours. The stronger hues and shadows were built up by shading with moist pencil points. The final, crisp colour details were added later dry-on-dry. The leaf colours were more loosely hatched than the flowers, wet and dry.*

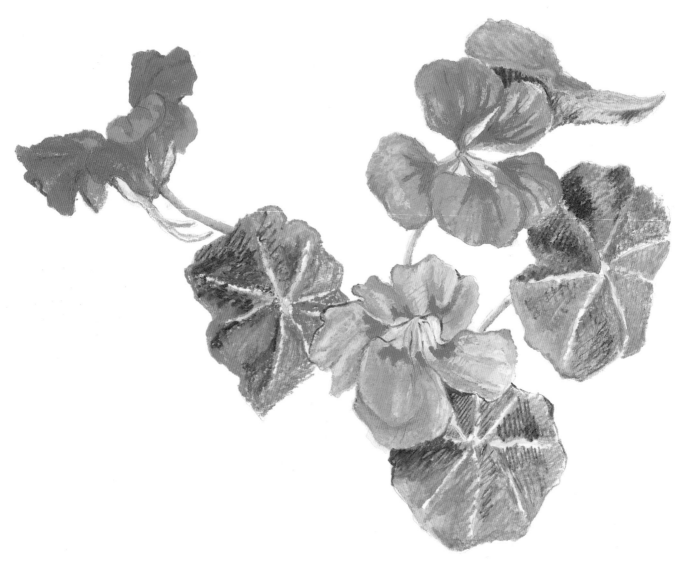

26

elegant shapes, so the outline of the drawing was extremely important. With watercolour pencils you can draw outlines quite precisely and feel that you have a firm guide for developing subject shapes, but the lines are gradually absorbed into the overall colouring of the picture as you work.

COLOUR

The intensity of flower colours is often startling. You can use the strong colour of the dry or wetted pencil tip to your advantage. In close-up studies it is usually best to work as directly as possible with the pencil colours at your disposal, looking for the nearest match you have to the colour of the subject. The nasturtium leaves were a more subtle green in reality, but I decided to work with the colours I had – a blue-green and a yellow-green, modified with blue, brown and red. Although the brightness of the leaves is not strictly realistic, it does nicely balance the vivid flower colours.

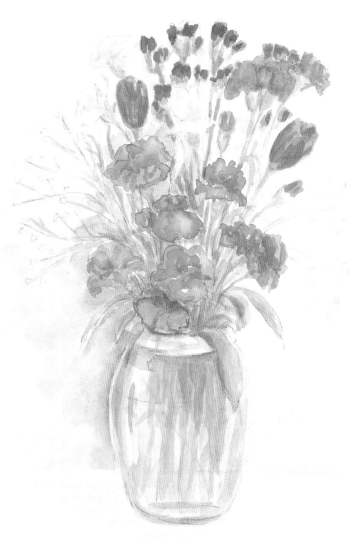

WATERCOLOUR PAINTING

Using the pencils almost purely as watercolour pigment gives a much more delicate effect than layered wash-and-line techniques. I chose to try this approach for the vignette of a vase of flowers (above right), first pre-mixing the colours on a paper 'palette' and working almost exclusively with the brush.

I made a sketchy outline drawing in water-soluble graphite, then brushed in the colours loosely and let the first layer dry out completely. I reworked in the same way to strengthen the hues and add a little texture, but avoided trying to sharpen up the drawing. A suggestion of cast shadow gave the image both depth and solidity; for this, I used water-soluble graphite washes, since its translucent, silvery grey quality was better suited to the style than an opaque, grey pigment.

▲ *A combination of brush drawing and light washes gives a charming impression on a small scale. You need to layer the colours carefully in order to build up the contrasts.*

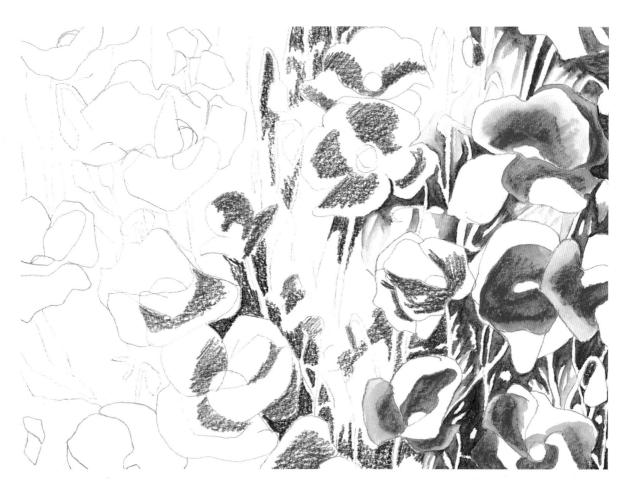

MASSED COLOUR

When your subject contains a lot
of detail, such as this mass of
poppies growing outdoors,
treating the individual petals and
leaves with layers of washed and
shaded colour is time consuming.
And when a lot of effort is
concentrated on the pencil points
while drawing, the style runs the
risk of becoming tight and
inhibited. I tried to solve these
problems in this picture by
moving back and forth between a
careful drawing technique and a
freer painting style. This helped to
suggest, rather than fully define,
the background detail, and to
keep the flower shapes and
colours bold.

I began by creating a simple
outline and establishing the basic
composition in only two colours.
Having worked right across the

drawing in this way, I then
started to apply very loose
washes of red, green and yellow
over the initial shading. There
was a danger of wiping out
everything underneath, but I
found it worked well provided
that I kept a light touch and made
certain that the washes were not
too wet. The general shapes and
tonal pattern were preserved,
but the image became more
expressive. I then reworked the
composition with dry pencils and
brush drawing in order to firm
up the shapes and to darken the
background shadows using
black over the grey.

▲ *The first stage was a formal plan
of the composition made in scarlet
lake and neutral grey pencils. I
worked quite slowly and precisely
to establish the basic shapes, and
used the brush tip to put some texture
into the washes.*

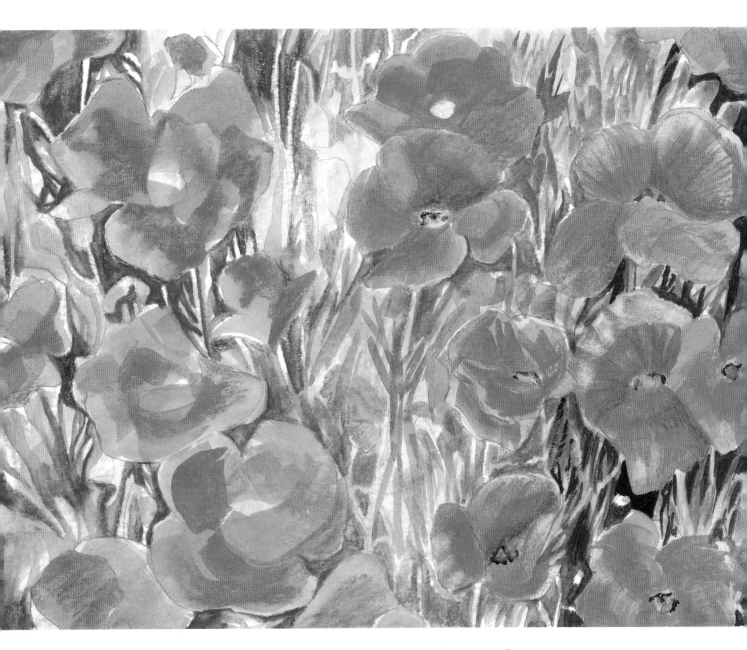

▲ Having completed the red and grey drawing and allowed it to dry, I blocked in with yellow, two greens and two reds (shown on the palette right), using a square-tipped brush to apply the colours quickly and freely. Having completed that stage all over, I began to work on the detail using dry pencils and a little more brushwork, introducing black, carmine and a darker green. I also used an eraser for highlighting the petals.

FOLIAGE AND TREES

The variety of shapes, colours and textures in trees and shrubs is fascinating and can be bewildering. In landscape work, where you see trees or bushes from far off, you can often get away with an area of simplified texture, using shading or wash. But if you are drawing a garden or close-up landscape view, you must create more definition.

Individual studies help you to build up a stock of information, both about the subject and the techniques you can use. You can plan to put them together in a colour composition, or use the sketches as general reference for outdoor subjects.

COMPOSITIONAL ELEMENTS

There are four main elements to deal with: the plant's overall shape; its colouring; the tonal structure that gives form; and the texture of its foliage. Avoid trying to deal with everything at once. First, get a general sense of shape and form by simplifying the colour scheme, using one or two colours to describe silhouette and tone. Then you can build up the textures and colour variations, although the tonal pattern is often the basis of a feel for texture, so there may indeed be not much more to do.

Let the character of the subject suggest a technical approach. To define the overall shapes of trees, use broad shading and washes.

▲ *A single-colour tonal pattern creates movement and texture within the tree silhouette. This can be reinterpreted with colour shading and localized highlights.*

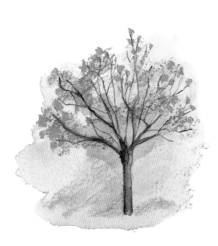

▲ *Bare branches can be sharply delineated over a dried-wash background. The sparse but bright autumn leaves were drawn with wetted pencil tips rolled across the paper to create a rough texture.*

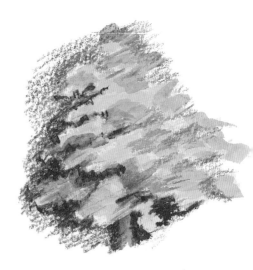

▲ *Using the direction of the pencil and brush marks helps to give shape and form to the overlapping layers of the golden foliage.*

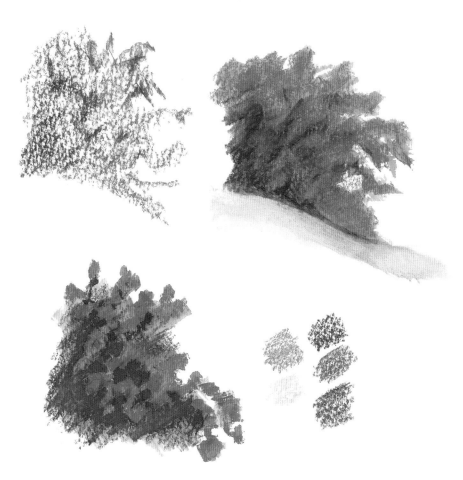

Bare branches or spiky grasses naturally depend more on line work, applied with a pencil point or a brush. You can develop variations of colour and tone by layering, alternating between dry and wet. A wetted pencil tip is good for rough, free textures and bright colour accents.

If you are making reference drawings for a finished work in coloured pencils, it is helpful to keep a record of the colours used. It is easy to forget how you arrived at a solution, and difficult to identify colours once they are mixed. I shaded small blocks of colour beside some of these sketches to remind me of the individual pencils.

▲ *In the detail sketch of this dark red shrub there are orange and yellow highlights on the foliage tips. The intensity of tone and colour was built up with wetted pencils, working into the mid-toned red and purple washes.*

▼ *Grassy, linear leaf patterns can be represented by pencil or brush drawings, using a selection of suitable colours that provide dark, medium and light tones.*

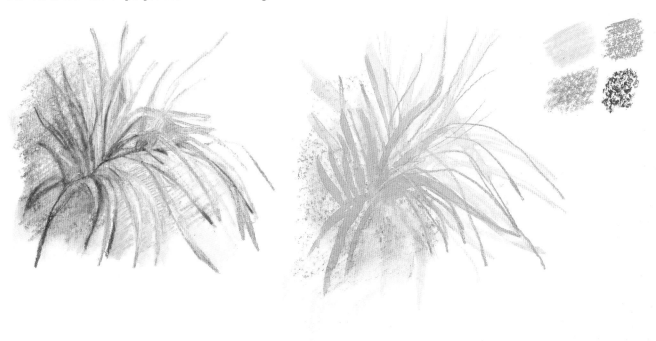

The sketchbook drawings reproduced on these pages were made as references for a planned series of acrylic paintings based on ornamental gardens. In these, I wanted to catch a quick impression of the general view and something of its mood, rather than record detail of the plants themselves.

Both views have an informal pattern of variable shapes made by the planting. One has an open perspective looking across the sloping garden to the townscape beyond (right). In this, the changes of scale are important in fixing a sense of space and depth. The large, conical tree in the foreground is so close that its top rises above the horizon line. It is also dense and dark, so everything

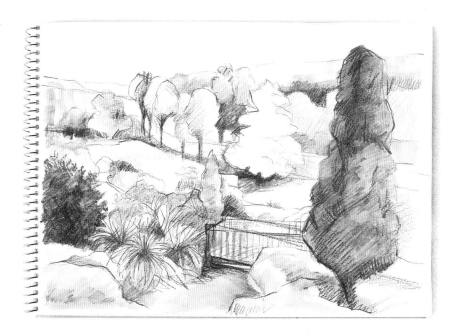

▲ *In a tonal sketch, a second colour can be useful to adjust shapes and add emphasis. Here a wash drawing in brown was made, reworked with harder line and shading in blue.*

▼ *This supplementary colour sketch includes some graphite pencil drawing and written reference notes.*

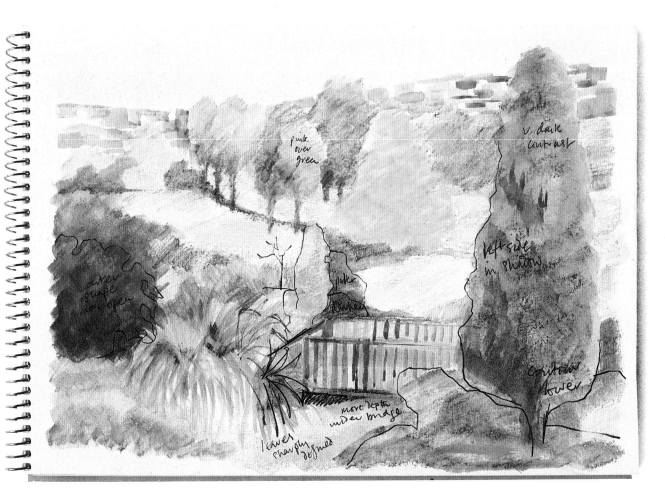

else is pushed back by its dominant shape. It is, to some extent, balanced by pockets of dark shadow in the receding landscape, and I have plotted that idea in the tonal sketch.

The accompanying colour sketch is no more than a map of the colour variations (opposite below), since I had plant studies and photographs that would provide me with important detail when it came to making the finished paintings of the view. However, I wanted to remind myself of some interesting touches that might be brought out more strongly in a painting, such as an unexpectedly light-coloured tree in the middle distance, with pale pinkish tints veiling the muted green foliage.

The sketch below is an autumn view of another garden, where the ground level was flat and I was surrounded by the trees and shrubs. The impression there was of very strong colour masses forming a semi-enclosed space. The intention was to record the density of colour and tone and the impact of the massed shapes, so I used wetted pencils very vigorously to develop strong colour accents and contrasts.

▼ *In order to work on a scale that allowed a very free approach to this drawing, I let it extend across both pages of the sketchbook. This produced a panoramic format, in which the colourful centre of the view was framed by tall, dense shrubs on either side.*

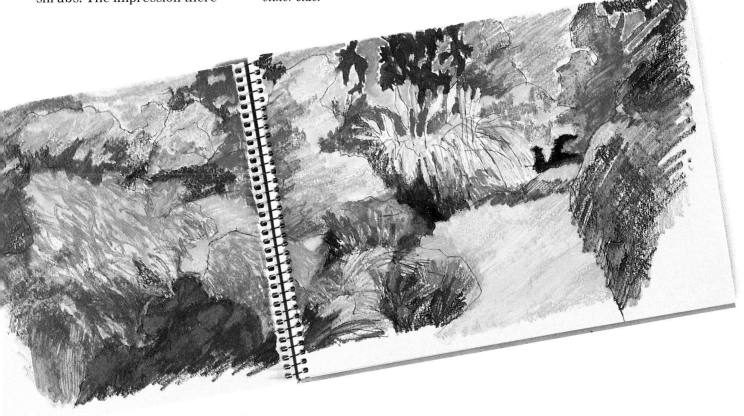

33

SUMMER GARDEN
DEMONSTRATION

The origin of this subject was a colour photograph, which I have used a number of times as the basis for drawings and paintings. Some of the detail in the snapshot is not too clear, but I like the overall sunny impression of the picture and the combination of shapes and textures. If you work from a photograph, it is easy to become bogged down in trying to copy it bit by bit. It is better to think of your drawing as an interpretation of the scene, not as a re-creation, and to use the pencils quite freely to develop textures and colour effects.

A pleasing aspect of this view is the sense of depth created by the receding flower border, framed on three sides by trees. This had to be established early on by broadly fixing the triangular shape of the lawn and the different levels of foliage. The tonal key was important; I wanted to catch the intensity of the sunlit effect, which is totally dependent on the pattern of light and shade.

COLOURS
Viridian; olive green; leaf green; May green; cedar green; terracotta; Vandyke brown; black; cadmium yellow; orange; scarlet lake; magenta; pink; mauve; violet; ultramarine; cobalt blue.

FIRST STAGE
On Bockingford 140lb (300gsm), I began by establishing some key elements to map the layout and

▲ *First stage*

▼ *Second stage*

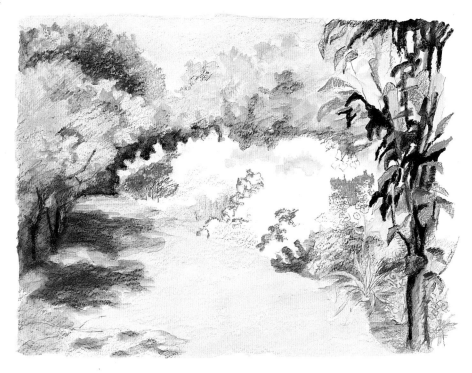

34

create the general proportions of the image. To set a tonal key, I drew the right-hand tree strongly, since it had the darkest tones. The broad colour areas were put in with free shading, mostly washed over with a damp brush to thin out the colours. In some places, the grainy pencil texture was left dry. A few bright colours gave a range for the mid-tones.

SECOND STAGE

This stage of the work mainly concentrated on deepening the shadows and varying the range of greens, adding blue-grey and terracotta as well as a dark olive green to tone down the brighter yellow-greens. The foreground tree was pulled well forward by employing both a harder drawing style and a more emphatic tonal contrast, using wetted pencil tips to make strong marks.

I handled individual textures directly, devising equivalents for massed and linear shapes in foliage or flowers by combining dry and wet pencil and brush techniques. The centre of the image contained practically all of the highlighting and pale tones, so I left some areas white while building up the surrounding colours.

THIRD STAGE

By this stage of the work, the tonal balance could have been thrown off-key by the large area of white at the centre of the picture. To counter this, I started to define the shapes and colours of the flower clumps by combining line drawing with light shading and washes. Although I had been blending and overlaying the leaf colours quite freely, it was important to keep the flower colours looking fresh, so I chose the nearest match for each hue and avoided mixing. Instead, I varied the tones between strong, dry colour and paler, brushed-out marks to create texture and shape. Because the scale of the drawing was relatively limited, I used small, round brushes, rather than flats, to define the delicate shapes.

▼ *Third stage*

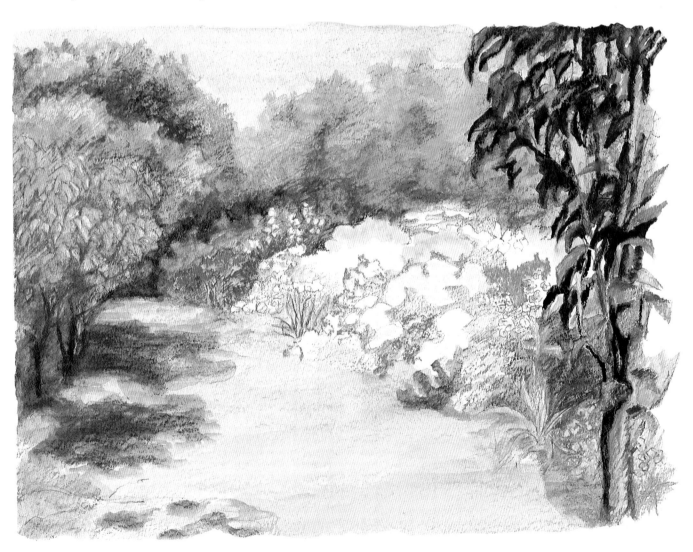

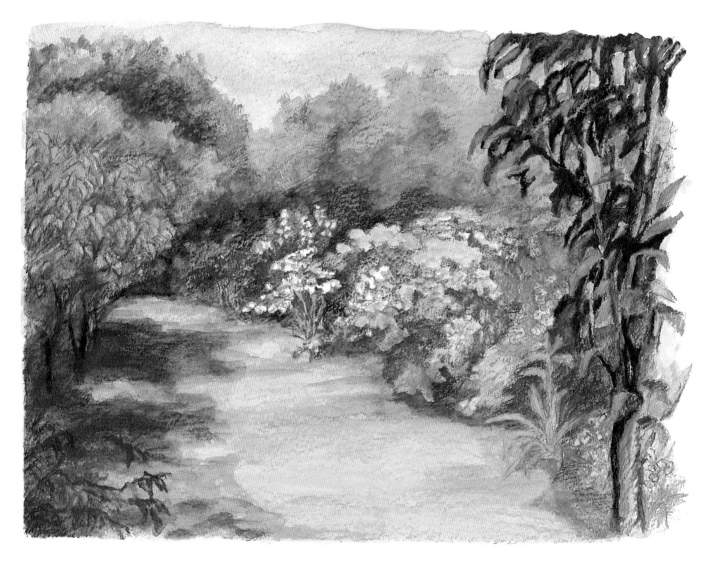

FINISHED STAGE

As I gradually filled in the colour areas, the overall pattern started to even out. I reworked the dark tones to put back more depth, building up with dry shading in violet and ultramarine. As well as tonal contrast, I could now exploit the contrast of complementary colours. The reds and yellows of the flowers naturally intensified the greens, blues and violets. As a finishing touch, a bright yellow wash lightly flooded across the whole lawn area, except on the bluish cast shadows, added brilliance to the light.

DETAIL

The flower shapes cannot be drawn precisely on this scale.

The main function of the flower masses is to create pockets of colour contrast and a different type of light that brightens the impression of the more consistent foliage colours. I have used simple combinations of line and shading to give a suggestion of form and texture.

▲ *Finished stage*
Summer Garden
23 × 31 cm (9 × 12½ in)

▲ *Detail*

SKETCHING LANDSCAPE

Watercolour pencils are ideal for outdoor sketching. These sketches make use of heavily wetted colour. But you don't need to carry much water, since it is used only to dampen the paper and moisten brushes.

Two techniques have been used: shading dry colour on to the paper and brushing it out with medium round and flat brushes, allowing colours to overlap or blend; and rubbing pencils over the wetted surface, rolling the sides of the tips into the moisture to build up heavy tones and ragged textures.

The first method works well for small sketches, in which the spread of colour is contained and details need to be kept small-scale.

The second can be used in a limited way for strengthening colours and tones in washes, or to create bold marks in larger sketches, where hand movements need not be inhibited.

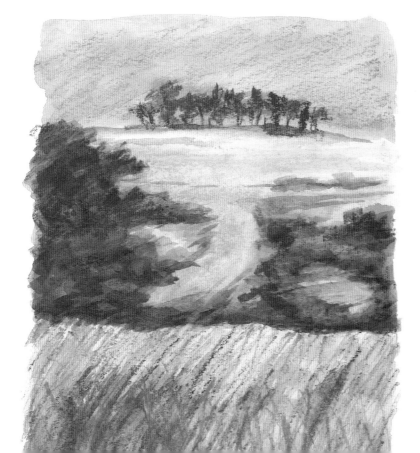

▲ *The greens and blues were thoroughly wetted and 'puddled' with a brush to make the shrubby masses, contrasting with the lightweight, dry-brushed texture on the grass.*

◀ *A brush was used for the smooth colour areas and textured foliage patterns in the middle ground, drawing with a pencil into the damp wash for the grassy foreground and distant line of trees. There was a distinct contrast in the colours of grass, shrubs and trees, with a warm cast in the darker tones, which was emphasized by using red-violet and terracotta with ultramarine.*

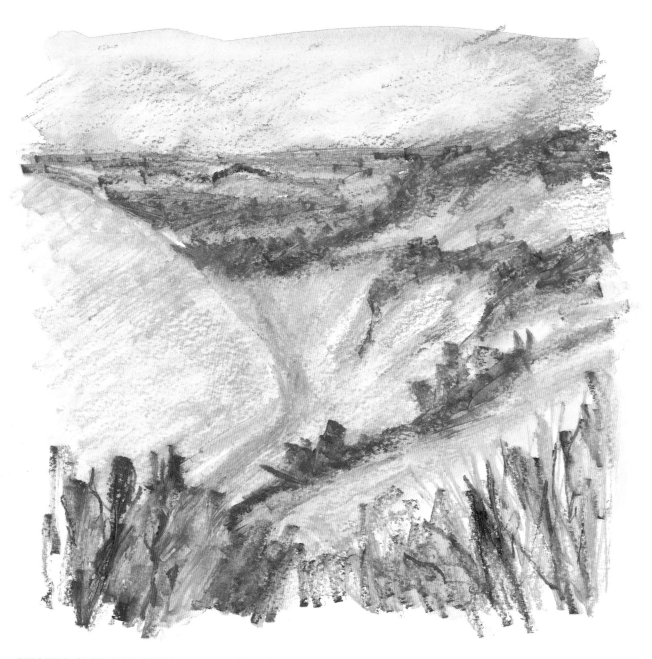

SHAPES AND COLOURS

A sketch does not have to contain all the detail in a landscape view to catch a sense of place. In these sketches, the lie of the land gives the main character of the drawing – broad slopes and high banks of ground forming an interlocking pattern. The different kinds of vegetation grow in ways that reinforce the underlying shapes.

Whether you work directly with pencils or with brushes, the texture and direction of the marks each tool makes can help you to describe the varied elements of the view. Isolate the main colour areas in your mind's eye and block them in broadly, keeping the colour application light to begin with. Pull the pencil or brush over the contours of the landscape, following the stresses of the pattern – horizontal, vertical, slanting.

Once you have a basic plan of the landscape blocked in, start to build up the colour strength and textures in different areas. Let

▲ *Rubbing with the sides of the moistened pencil tips created the vigorous, textured marks in this sketch. Strong summer light reduced the contrasts, and I was looking at the basic pattern of the landscape.*

your brushes travel evenly to smooth out flat slopes and distant planes, then 'worry' at the textures of grass, shrubs and trees, using quick, vigorous strokes of the brush or pencil tip.

CREATING CONTRASTS

Since watercolour pencils are lightweight and easily portable, you can carry as many colours as you wish. But it is often useful to restrict your colour range for an individual sketch, thinking about the overall mood of the light and landscape. Too many colours can easily confuse the composition and, in practical terms, it is easy to overmix and muddy them. Try using no more than about five or six pencils that reflect the natural hues and also give you a simple range of dark, medium and light tones.

Look for sharp tonal contrasts; shrubby masses usually show up darkly against open grassland, for example, but you will also find ridges of more subtle tonal variation where the land dips or rises in steps. Even, bright light can flatten tonal modelling, giving emphasis to local colours and surface textures; but in the low sunlight of a late summer's afternoon or a bright winter's day, there is typically a more dramatic tonal range, including heavy cast shadows that cut across the ground planes.

Colour contrasts help both to shape the view and to develop a seasonal mood. Summer light gives freshness to the bright greens and yellows of grass and foliage; autumnal changes bring tints of warm orange, red-purple and brown. Deep blue and violet are cool colours that naturally suggest depth and distance, but they are also good shading colours when seen against orange and yellow because they are directly complementary.

▼ *In order to build up the density of the shadows and silhouetted foliage shapes, thick impasto colour was created by working wet-into-wet with the tips of the pencils.*

◀ *Using a controlled technique of brushed-out pencil shading allowed the cloud masses to be modelled in a range of graduated tones.*

▼ *Blotting the colour with a tissue produced soft, tonal variations in the sky. The wash has to be very wet to make the loose texture.*

SKIES IN LANDSCAPE SKETCHING

It is often easiest to make the sky just a simple background to the general landscape view, treating it as an overall colour wash. If it is a blue sky, you may find that you obtain a more natural colour from mixing a couple of blues together, depending on what is in your set – ultramarine, for example, may be too dull, while a 'sky' blue pencil is too bright. However, a sky does not have to be blue or grey, and you have the option of keying it to the colour mood of your sketch – yellow, orange and violet are useful sky colours, or even reds and pinks for twilight or evening skies.

Achieving an even, flat wash of colour can be difficult, but it is usually more effective to have a little movement and colour gradation in an area of sky. Alternatively, you can manipulate the direction of your pencil and brush marks – as for the landscape – to create loose cloud masses or heavy, thundery skies. Blotting the colour with a tissue is a simple but useful technique

for lightening the tone if you have overdone it a little, and blotting is also an effective technique for providing soft, atmospheric textures. Try using an eraser to bring back the light into a dry wash, or overlay the colour with opaque white and pale-coloured pencil shading.

▼ Heavy shading and open hatching, thoroughly wetted and allowed to run freely with the paper tilted, suggested an atmospheric, rainy sky.

▲ A combination of shading and blotting into damp washes produced a freer, more active effect.

DOWNS VIEW
DEMONSTRATION

This painting displays a tighter style of landscape drawing. It was done in the studio from sketches and photographs, allowing me time to build up the image in a controlled way.

I was interested in the general impression of space and distance and the sweeping curves of the downward slopes. For the overall scheme, I decided to use the different qualities in my range of green pencils, rather than mix and modify them with other hues. The blue-greens, such as emerald and viridian, are rather too 'sweet' for natural landscape colours. I used viridian mainly in the background, where the bluish tinge was appropriate for suggesting distance.

COLOURS
Cadmium yellow; raw sienna; viridian; olive green; leaf green; May green; juniper green; ultramarine; violet; crimson; white.

FIRST STAGE
The fundamental divisions of the landscape were established using a basic colour code, shading broadly with dry pencil tips and brushing out these marks wetly into quite loosely washed areas of colour. I took advantage of the directions of the brush marks to give a sense of the shape and pattern of the interlocking planes. As the colour was spread thinly, the paper grain (Bockingford 140lb/300gsm) also contributed an open, slightly rough texture.

▼ *The square format of the picture was chosen to position the cleft centrally through the landscape and to create a foreground-to-background emphasis – rather than a broad, horizontal spread.*

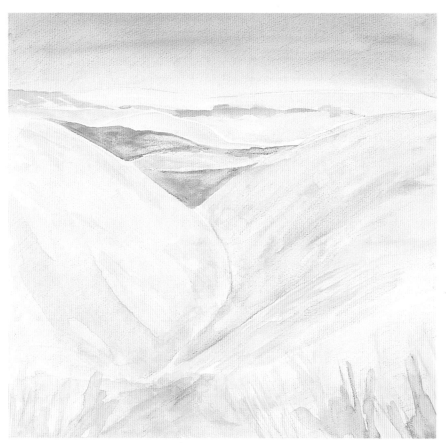

▲ *First stage*

SECOND STAGE

In further washes to build up the colour strength, the greens were graded from the bluish horizon towards the brighter yellowish hues in the foreground. This gradation was achieved both by separating the different qualities of green and by mixing in ultramarine, cadmium yellow or raw sienna. I started to develop the detail of the foliage textures with dark-toned olive and juniper greens, combining dry shading and damp brushwork with wet-pencil impasto. The foreground flowers were indicated with crimson washes.

FINISHED STAGE

I made more use of dry pencil drawing to enhance the contrasts and to give a grainy texture to the land, overlaying the darker-toned greens with violet and brightening the bushes in the middle distance with leaf green and yellow. This stage involved a continuous reworking back and forth across the composition to build up colour, shape and texture.

The brighter colours of the grasses and flowers in the foreground were applied with wetted pencils, rolled and scrubbed to develop textural detail. This also helped to enhance the sense of scale and, with the stronger reds, brought the flowered area forward, making the layering of the landscape more marked. I shaded with ultramarine from the sky down over the horizon to 'knock back' the distant fields, and then used a white pencil, dry and wet, to heighten shape and detail in the middle ground and foreground.

▶ *Finished stage*
Downs View
36 × 37 cm (14 × 14½ in)

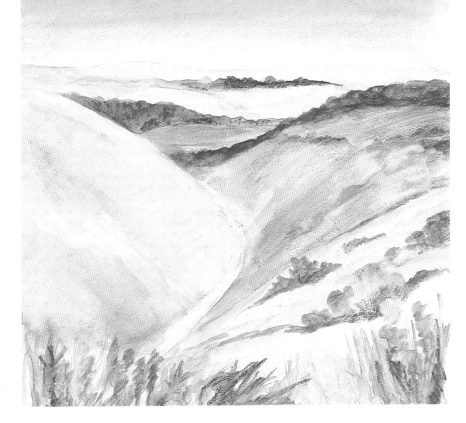

▲ *Second stage*

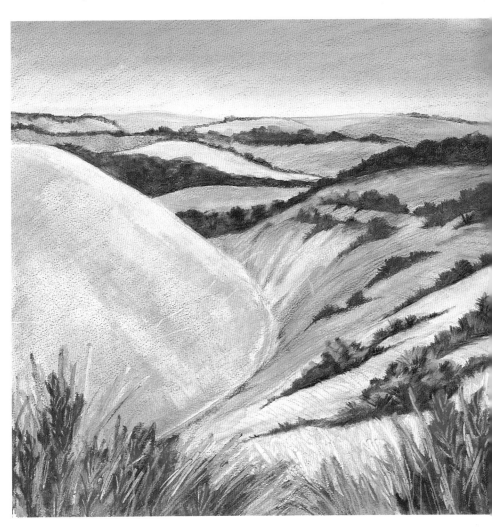

DRAWING ANIMALS

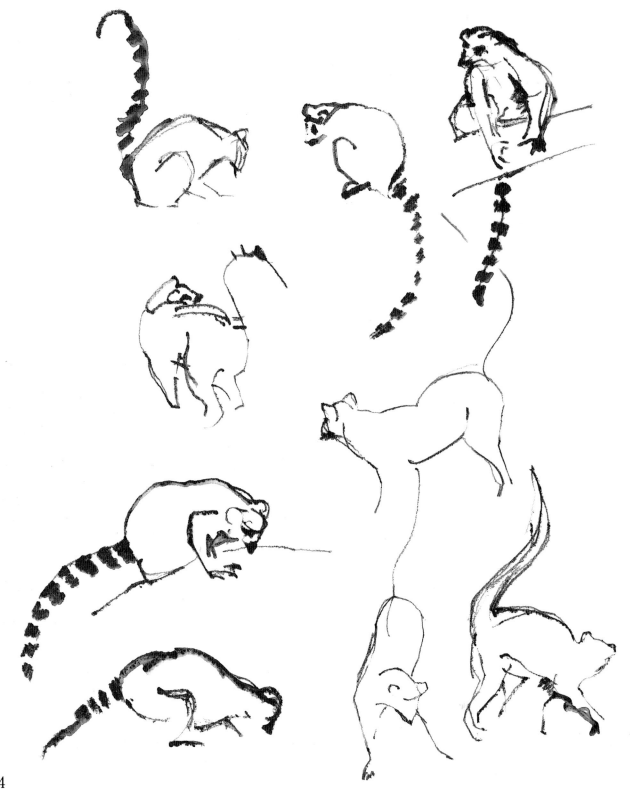

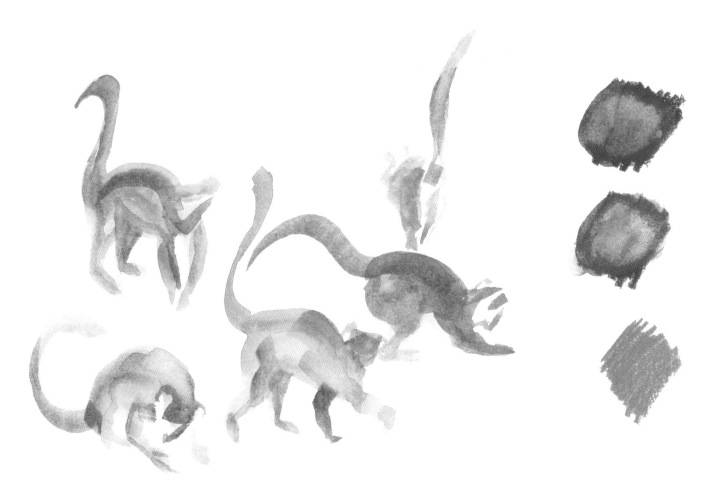

▲ *The directional flow of a flat brush showed more of the animals' bulk and the turn of their bodies and limbs.*

Watercolour pencils are a particularly good medium for animal drawings because of the variation of texture you can develop using the pencils dry or wet. Whatever your medium, there are always difficulties in trying to draw a moving subject, and the quickness of the pencil is vital if you are sketching from life. More detailed studies can be worked up from sketches and photographs. You can exploit broad colour washes to help you to create the body of the animal, and use point work, wet or dry, to build up the texture and pattern of the fur, feathers or scales.

QUICK SKETCHES

Adjust your technique to suit the circumstances. Whether you are sketching a family pet, farm animals outdoors or zoo animals in enclosures, their movements are unpredictable and they rarely hold a pose for long. You need to try to catch them at rest, or when performing such slower, repetitive actions as washing or eating.

When drawing something that is fleeting, use a single pencil and concentrate on line work. Look at outline shapes for the bulk of the body – the way limbs are angled and articulated, the turn of the head or the curve of the tail. Simple line drawings, if freely described, can be very telling. Let the pencil feel its way around the form on the paper. You can develop line qualities using the tips sharp or blunt, dry or moistened.

Direct brush drawing is also a quick method and it gives a sense of the animal's solidity. As with the pencil point, just let the brush follow the form and movement.

◄ *In rapid line sketches, the heavy swell of the wetted pencil tip naturally tapered into a finer line as the moisture ran out, which helped to suggest the sense of movement.*

LEMURS FEEDING
DEMONSTRATION

This is a composite picture put together from details in three photographs. I liked the various contrasts in the image: the one curled and one elongated shape; the gentle greys of the body fur against the starker black-and-white heads and tails; and the way those neutral colours also contrasted with the brightly coloured scraps of fruit. I preferred to silhouette the image, rather than put in a background, to emphasize all those elements.

I intended it to be a delicate study, so the colour layers were developed gradually. Always think about how you can vary your technique appropriately for treating different components of the picture. For example, note the free brushwork applied to the weathered surface of the rock, as compared with the delicate washed tints and fine-line shading of the animals' furry backs.

COLOURS
Mid-grey; blue-grey; terracotta; raw sienna; scarlet lake; orange; cadmium yellow; ultramarine; May green; olive green; cedar green; black; white.

FIRST STAGE
I began by mapping the shapes lightly but precisely with graphite pencil (on Bockingford 90lb/190gsm), and started to establish the colour tints. On the left-hand lemur, blue-grey is the dominant colour of the fur, while on the right-hand one the warm brown

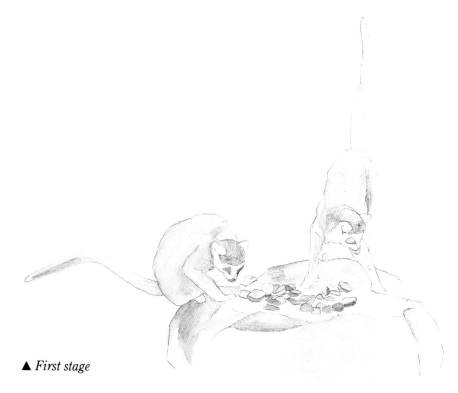

▲ *First stage*

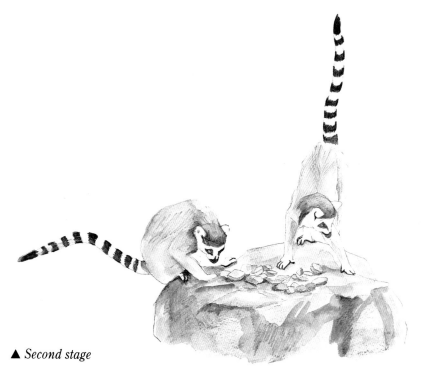

▲ *Second stage*

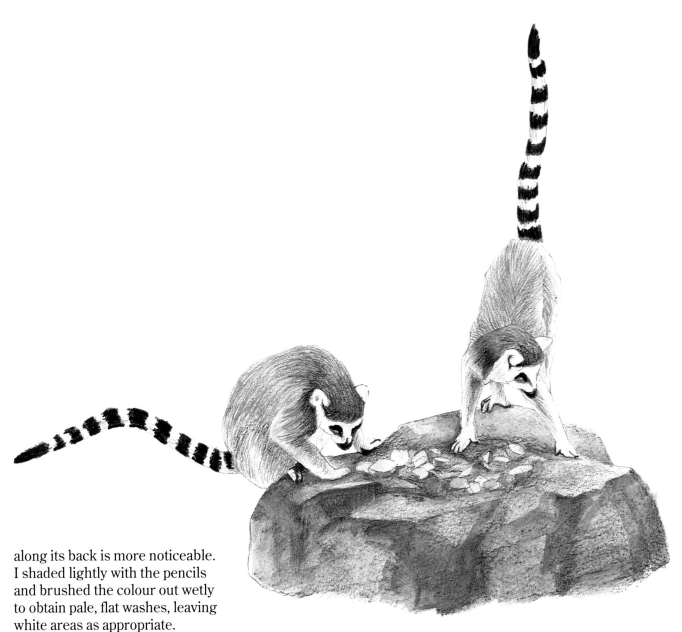

along its back is more noticeable. I shaded lightly with the pencils and brushed the colour out wetly to obtain pale, flat washes, leaving white areas as appropriate.

SECOND STAGE
The strong black-and-white contrast of the animals' tails was a key factor, against which other tones and colours had to be judged. I drew the black tail rings with a wetted pencil tip and then began to harden the tone and detail in other areas, alternating between pencil shading and wash, with dry line work overlaid on dried washes. I kept reworking individual elements of the lemurs and the rock in sequence in order to create a satisfactory balance of tones across the image overall.

FINISHED STAGE
Once the washed colours had built up to a solid, strong image, I used dry, well-sharpened blue, grey, brown and black pencils to sketch the fur with light strokes, crosshatching to integrate the colours. I put some blue shading into the whites, which had been cleaned up with an eraser, to give a more rounded look to the lemurs' tails and to add depth to their faces. Dry shading on the planes of the rock contributed a grainy texture and heavy tone; I brightened the colours of the fruit pieces to enhance contrast.

▲ *Finished stage*
Lemurs Feeding
22 × 26 cm (8½ × 10½ in)

CHINA AND GLASS

Everyday objects, such as cups, jars, bottles and jugs, make useful components for simple still-life arrangements that you can readily use for practising your drawing techniques. What they have in common are regular shapes and hard, reflective surfaces – qualities that exercise your skills of both observation and interpretation. This does not mean, however, that one method of drawing them is more effective than another. You still have scope to vary the style of your drawing and its range of detail, utilizing the characteristic marks made by watercolour pencils.

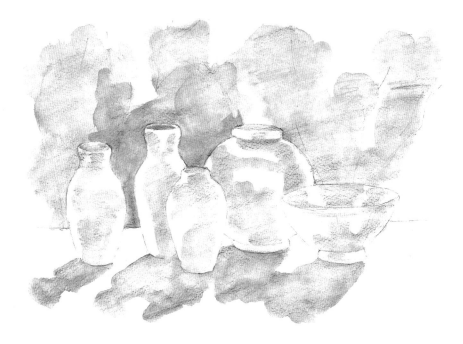

▲ *The tonal pattern of this still life was complicated by the surface detail of the vases, so I began with simple tonal washes, using water-soluble graphite.*

DEFINING FORM

When you are dealing with hard-edged, well-defined shapes, your eye is naturally drawn first to the outline or silhouette of the object. The regularity of rounded or cylindrical objects is difficult to achieve, especially the complete ellipses and elliptical curves that represent the horizontal cross-section of, say, a cup or jar; but these locate the variations of tone and colour within the shapes that give form to the object.

It is good practice to sketch a group of objects quite simply, thinking just about basic shapes and reducing the surface detail to a minimum. Let your pencils travel freely around the straight lines and curves, then try adding some basic tonal shading and an indication of local colours to 'fill out' the shapes.

Watercolour pencils can be a fairly precise medium, but you do not have to get everything right in a sketch, or even in a more detailed drawing. You can erase the colour or dampen and lift it out, and then rework the picture to harden up the forms again.

PLANNING YOUR DRAWING

If you want to work up the detail in a finished composition more meticulously, ending up with a tight, hard-edged drawing style that matches the character of the objects, then it helps to begin with a carefully defined outline drawing. If the basic shapes you create are irregular or out of proportion, the development of

the composition will tend to emphasize such problems rather than disguise them.

Working directly in colour seems to be more of a commitment than plotting in pencil, so try using water-soluble graphite to make the initial drawing. You can sketch freely around the forms, gradually tightening up the outlines until they satisfactorily describe the regular shapes, erasing any incorrect lines as you go along. Don't press too hard, or the lines will be impressed into the paper and your erasures may show up later through the colour.

Another way of working is to make a separate, initial pencil drawing that enables you to explore the shapes, correct it as necessary and use it as a basis for a traced layout on which you can start straight away in colour. An advantage of a traced outline is that you can fold the tracing over on itself to check whether symmetrical shapes align – the sides of a vase, for example.

SURFACE PATTERNS

China with a painted or printed design is attractive to draw since you have more colour detail to play with. A superimposed pattern can also help to define the three-dimensional form of an object, because it is wrapped around the shape. However, with more surface detail to observe, the relationship between colour and tone is more intricate.

For example, in the still life of vases that I have worked up here, the vase with a black pattern is

▼ *As the patterns were built up in colour, the forms began to flatten out again. Some light graphite shading was brushed in over the colours and the highlights were emphasized by erasing and overworking in white.*

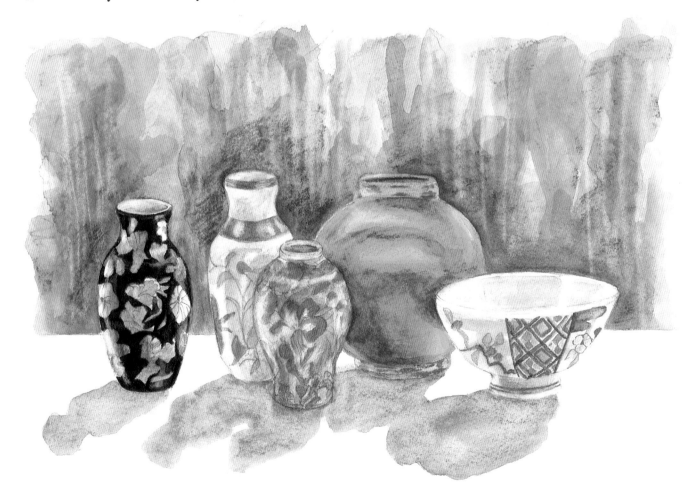

not uniformly black, because the interplay of light and shadow creates gradations of tone; this potentially applies to all the surface colours. You can simplify the interactions of tone and colour, but you do need to study the influence of light and shade, or the objects will look flatly graphic when you complete the colour drawing.

TRANSPARENT OBJECTS

Glass is a confusing material to draw because, although you can see through it, the surface is highly reflective, so there are different layers of visual information to sort out. The easiest way to handle this is to stop thinking about the spatial organization of the objects once you have plotted their basic

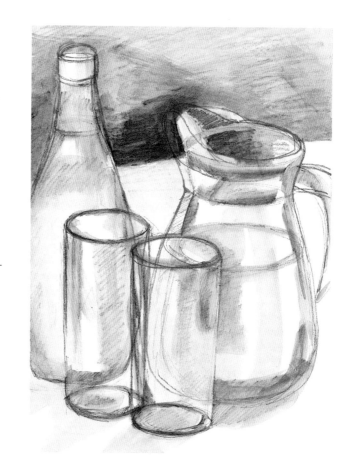

▲ *A preliminary graphite wash sketch helped to plan basic shapes and tones. Red pencil lines were used to correct the silhouettes and also as guidelines for the colour drawing.*

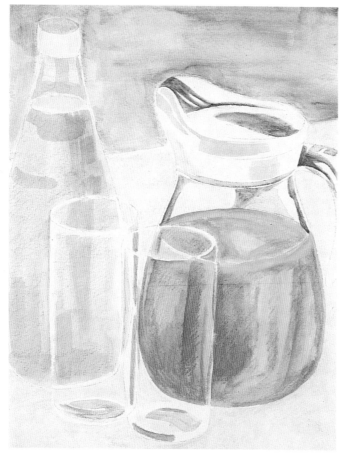

◄ *The first colour washes were mainly applied to fill out the basic shapes, but I had already begun to look at the reflected colours that helped to define the specific edge qualities.*

shapes, and try to visualize the detail as a flat arrangement of tones and colours. This is, after all, how it is going to appear when you put it down on paper.

Try to identify what actual colour you are seeing; its tonal key – light, medium or dark – and how much of the overall shape it occupies. Start with broad colour areas and refine internal shapes and details gradually. Use the various marks and textures of the watercolour pencils to respond to the colour qualities, blending washes smoothly where you see a slight gradation, overlaying brush marks on flat wash to indicate harder-edged, reflected shadows, or drawing with the pencil tips to sharpen up clearly defined shapes.

Because there are three-dimensional layers to a still life, you may see unexpected effects. Reflected colours often show up quite separately from their source. For example, glass picks up tones and colours not only from objects in its immediate vicinity but from anywhere in its surroundings. An intense colour accent may be thrown up by something in the still life itself, or a bright highlight could be coming from a window on the opposite side of the room. Make use of such elements where they will help you to emphasize the shapes and forms.

Pay particular attention to distinct tonal contrasts, especially in the final stages of the work. These contrasts often follow linear detail in the subject and they help to redefine the silhouette and basic, component shapes. Hard contrasts put the final 'glaze' on the reflective surface, so use your darkest and lightest tones firmly yet discreetly to give things an edge.

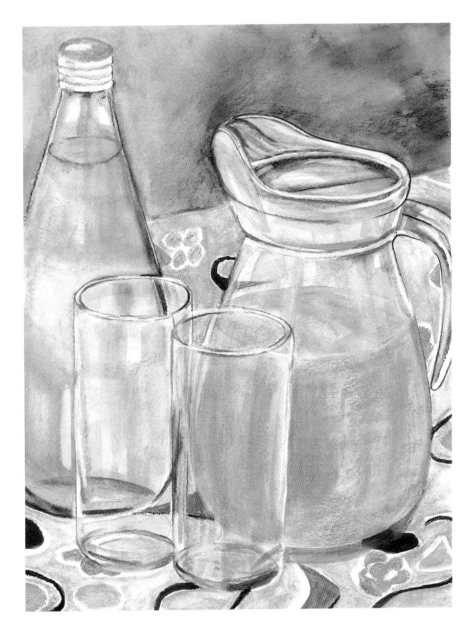

▲ *As the colour values were built up with successive layers, it was also necessary to rework the balance of tones continuously. Hard line drawing around the rims and bases made the objects stand out more three-dimensionally, as well as enhancing the glassy effect.*

CHINESE VASES
DEMONSTRATION

These little Chinese vases are decorated with a lively, brush-painted design, which suggested the free approach adopted in this still-life drawing. I chose pattern elements to fill the rest of the composition – sheets of gift-wrapping paper and a paper fan.

I wanted to use a strong, but also sketchy, approach, and so decided to work on a relatively large scale, using very thick, waxy pencils. It is important to bear in mind that the thicker and bolder the pencil marks, the more difficult they are to erase. To avoid having to worry about whether things might go wrong at some stage of the work, I decided to use white gouache as both a highlighting and correcting medium.

Gouache is opaque if brushed on thickly. If thinned down, it subdues colours sufficiently to allow them to be overworked. If using gouache as a correcting medium, allow dampened pencil colours to dry out completely, otherwise the colour will bleed up through the white.

COLOURS
Terracotta; scarlet lake; Vandyke brown; blue-violet; kingfisher blue; raw sienna; cadmium yellow; black; blue-grey; white.

FIRST STAGE
I used the heavy pencils, dry and wet, to draw bold outline shapes, and then roughly shaded and scribbled in the main colour

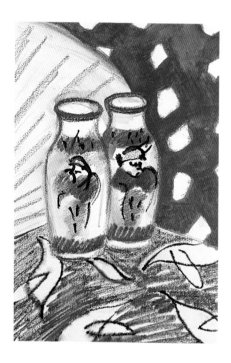

▲ *First stage*

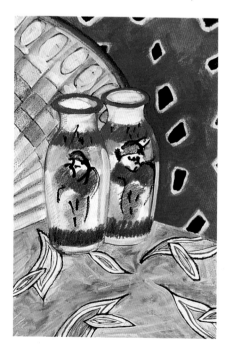

▲ *Second stage*

areas. The red-brown mix at the back was brushed out in layers to create solid colour. Since the black detail on the vases was a defining element of the style, I suggested it even at this early stage, using a wetted pencil tip.

SECOND STAGE
The black lozenge shapes were painted into the background by shading and brushing out, and then outlined with dry yellow. The foreground was loosely brushed over with white gouache, allowing the colours to mix and create the soft, silvery grey tones. As I worked on the surface patterns of the vases and fan, I wanted to keep the style free. Any problems with shape and definition were corrected by overpainting thinly with gouache and reworking.

FINISHED STAGE
I added strength to all the tones and colours, and gradually sharpened up and defined the detail. I wanted to preserve the abstract qualities of the patterns at the same time as developing a sense of form and space within the composition. The dark shadow behind the vases, loosely shaded and brushed in grey, made a considerable difference to the three-dimensionality of the picture. I lowered the tone of the background on the other side correspondingly, and added more colour and white highlighting to the vases to balance the shapes.

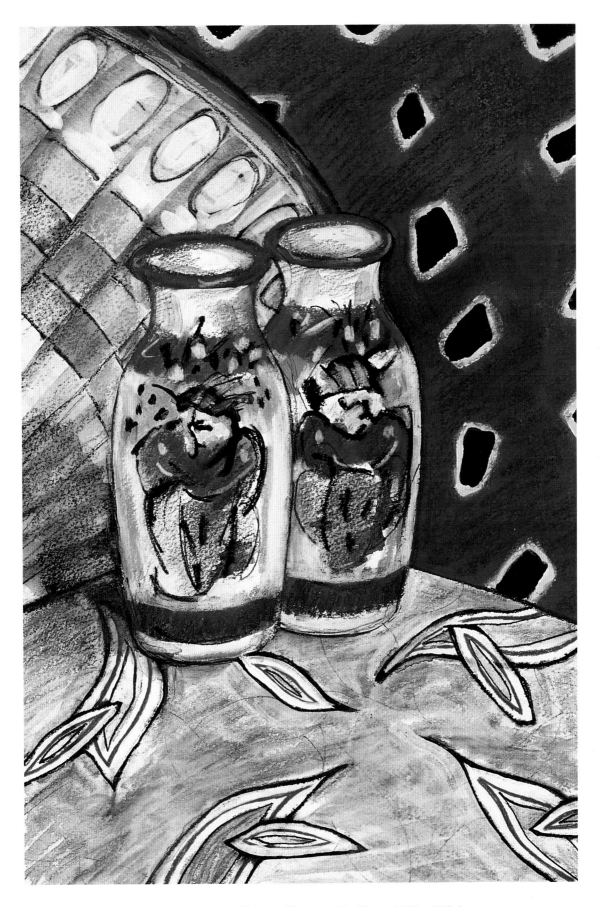

▲ *Finished stage*, Chinese Vases, *34 × 24 cm (13½ × 9½ in)*

MIXED MEDIA

Watercolour pencils combine sympathetically with watercolour paints, making them natural partners for a mixed-media approach. Using watercolour paint enables you to cover the paper more quickly and freely than you could with pencil shading and washes, especially when you want to work on a large scale. Paint colours can also be applied more strongly in a single stage. This allows you to create a broad coloured ground for your composition, which can then be given variable detail and texture with the watercolour pencils, used wet or dry.

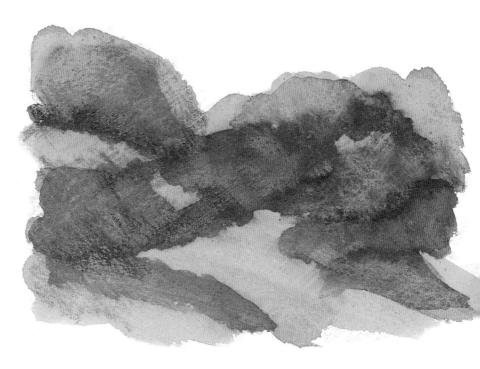

HARMONY AND CONTRAST

The paint and pencil combination provides a diverse range of visual effects and colour moods, depending on how you vary the textures and how much you allow the watercolour to show through the pencil marks. Another factor that influences the final result is whether you use harmonizing colours or play off colour contrasts.

The more difference there is between the paint and pencil colours, the less moisture you can apply, otherwise the colours merge and become muddy. The opacity and linear textures of the dry pencils are more important in this case, but you can soften and blend the marks by working lightly with a damp brush.

▲ *This effect was created with contrasting colours – ultramarine, cerulean and mauve washes – shaded over with olive green, May green and yellow. The lightly brushed pencil colour unified the shapes, but the undertones gave depth and form.*

◄ *Using harmonious colours is in some ways less easy than applying contrasts, since you have to play into the base colours rather than against them. Line qualities and tonal variations are more important in creating form and depth.*

54

CLIFF PATH
DEMONSTRATION

You do not need to have a large stock of paints in addition to the pencils for a mixed-media picture – the washes in the first stage of this demonstration, for example, were all mixed from just four colours. The colour range that you choose should obviously reflect the type of subjects you might want to tackle, as well as how often you are likely to use the technique. It is particularly suited to landscape work, but it is also worth trying for flower subjects, still-life compositions and townscapes.

Often it is important to reserve the white of the paper you are working on for highlighting. To do this, many watercolourists commonly use masking fluid. This liquid rubber compound is opaque white when wet but dries as a clear, water-resistant layer that prevents the underlying paper from receiving washed colour. It is easily rubbed off when you want to expose the masked areas. I used it here to mask out the hard-edged shapes of lamp posts and path wall in the first, free-painting stage.

Masking fluid can spoil brush hairs and is difficult to remove from them once it has started to dry. You can use a matchstick or the wooden end of a brush for applying the fluid.

COLOURS
Watercolours: cadmium red; ultramarine; cerulean; cadmium yellow. Pencils: cedar green; olive green; leaf green; May green; yellow ochre; raw sienna; terracotta; Vandyke brown; blue-grey; ultramarine; cobalt blue; violet; water-soluble graphite.

FIRST STAGE
I sketched the layout in water-soluble graphite, then painted out the lamp posts and path edging with masking fluid. The sombre, wintry colours were part of the subject's attraction, so I mixed the watercolour washes to convey this from the start.

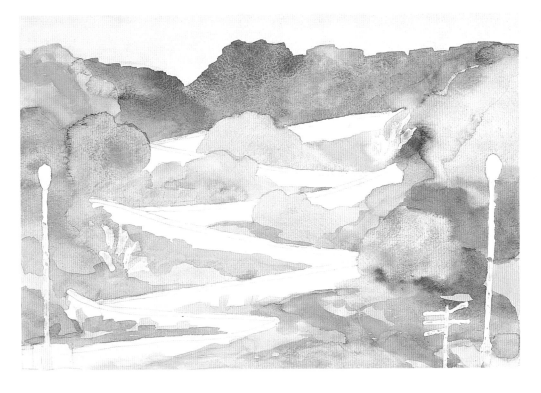

▲ *First stage*

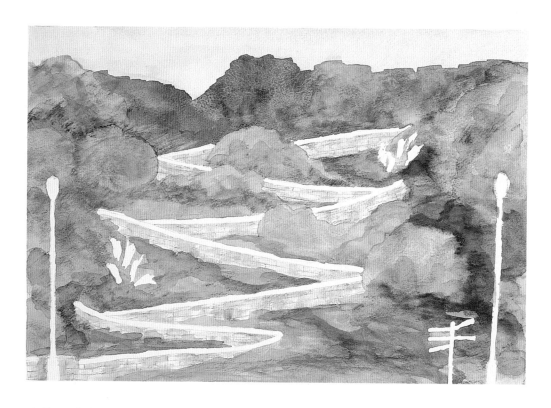

▲ *Second stage*

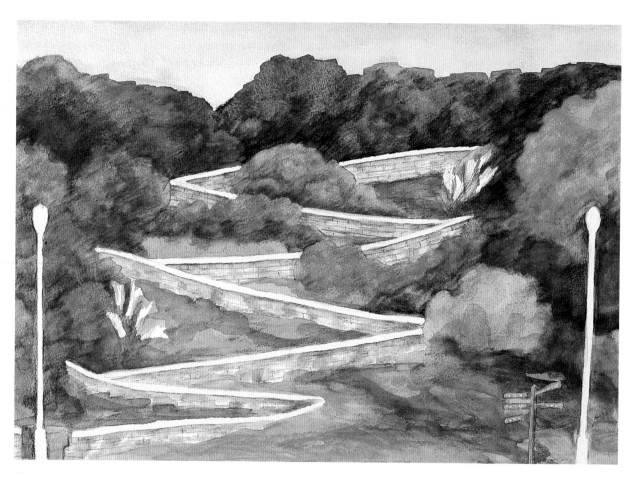

▲ *Third stage*

SECOND STAGE

The pencil shading was applied to firm up the shapes and give depth. I used yellow ochre and leaf green to brighten the tops of bushes; blue-grey, Vandyke brown and cedar green to emphasize dark and mid-tones. The bricks on the wall were finely outlined in brown and shaded with blue-grey. I used a damp, rather than wet, flat brush to feather and blend the pencil colours, to avoid picking up the still-soluble washes underneath.

THIRD STAGE

As pencils are more controllable than paint, I had peeled off the masking fluid by this stage and worked around the white, linear shapes quite carefully. I continued applying layers of dry shading and moist brushing to build up the density and textural variation. To enliven the colouring, in some areas I introduced warm terracotta and raw sienna over the greens, and used violet and ultramarine to deepen the shadow tones.

FINISHED STAGE

The sky tone seemed to fade as the foreground colours gained in intensity, so I reworked this area with a light wash of ultramarine. To adjust the colour contrast and tonal balance in the foliage and grass, I heightened the bright greens in the foreground and darkened the blues and violets.

I corrected irregular edges in the foreground by shading down the sides of the lamp posts against a ruler edge, and then brushed outwards from the hard lines to integrate the pencil marks with the preceding layers. I modelled the lamp posts in monochrome with soluble graphite pencil to give them a hard sheen that would stand out against the colours.

▼ *Finished stage*
Cliff Path
25 × 36 cm (10 × 14 in)

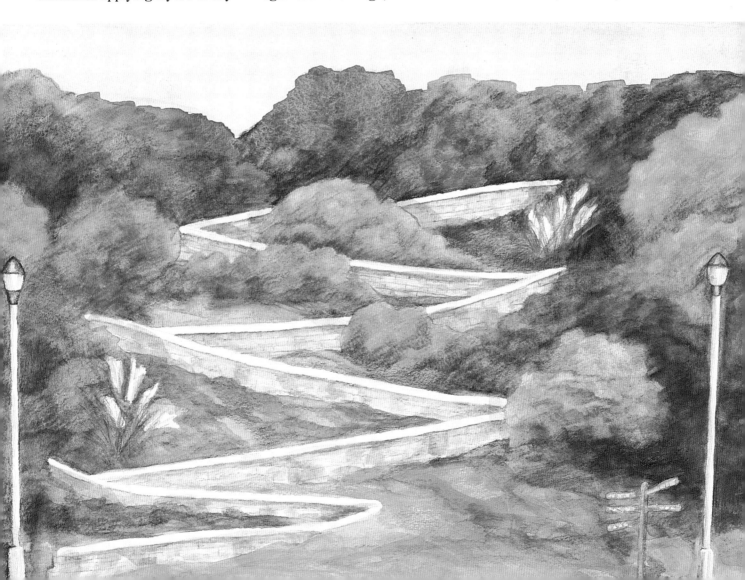

COLOURED PAPER

Working on coloured paper is a traditional method for crayon and pastel drawing and also for painting in gouache, which are all opaque media. It also works for watercolour pencils because direct pencil marks are opaque and washed colours are translucent, rather than transparent like watercolour paint, so they partly cover the underlying tone of the paper. You can gradually build up the colour effects by overlaying washes and using the pencils dry to make the shading more intense where required.

This method is particularly suited to subjects that have a restricted or muted colour range but a broad tonal scale, such as architecture or townscape. The basic principle is to use the paper colour as a mid-tone and apply the pencils to developing both the lighter and darker tones. Neutral-coloured papers, such as buff, brown and grey, work well as a general tonal background.

Stronger coloured grounds that have a distinct hue similarly provide a tonal key, but they tend to influence the applied pencil colours more actively. The colour can set the mood of the drawing: blue, for example, contributes a cool impression to highlights and shadows, where yellow or orange would provide an underlying warmth. It is also possible to use the paper colour as local colour – that is, to stand for something in your subject, such as a green

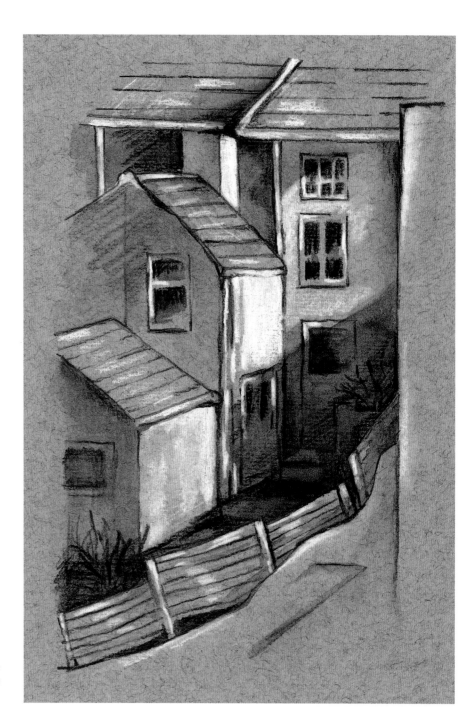

▲ *A neutral grey Ingres paper was used as a mid-toned background for this drawing in black and white.*

58

ground for a landscape or red for a still-life composition of flowers and fruits.

Suitable papers are coloured cartridge, Ingres and pastel papers. The initial washes 'sink' into the surface, so you need to strengthen the image gradually.

Two or three layers of shading converted to wash can be applied, but once the surface is partly sealed you will find that the colour starts to move under the brush. You may then find that you pick up almost as much as you put down.

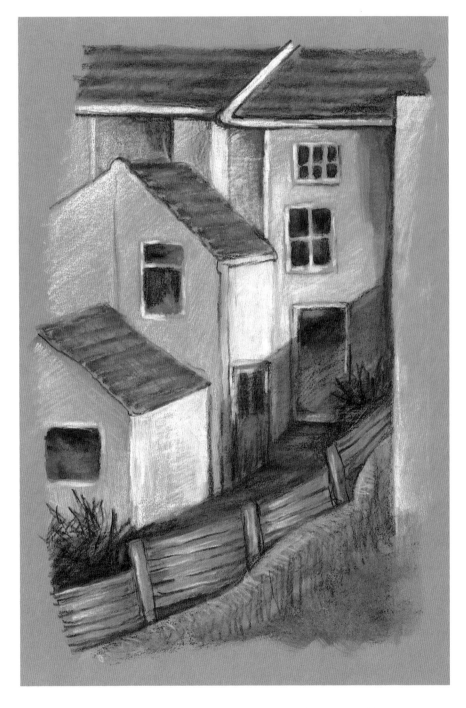

▲ *Blue paper modifies both the tones and the colours in this version of the scene, giving a cool tinge to the washed whites and a vibrant complementary contrast to the orange and red-brown roof tiles.*

Tip

● Select a paper with a slightly roughened surface that has a 'tooth' to grip the colour, otherwise wetted pigments tend to keep moving as you brush out the marks.

▶ *A demolition site, where only the scaffolded façade of the building still stood, was interesting for the way the bright light of the sky came through the apertures from behind. I made a simplified, semi-abstract pattern of the shapes and started with basic colour washes.*

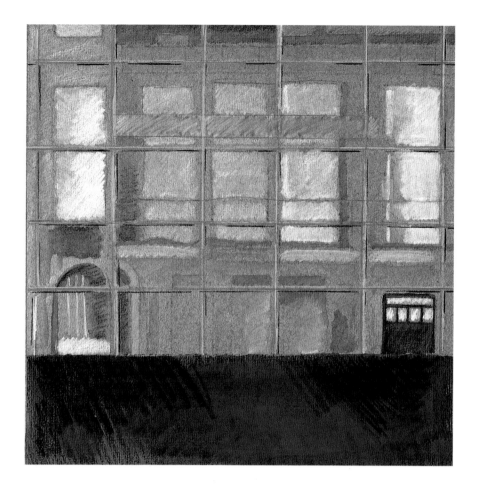

▼ *I gradually added to the detail in successive colour layers and, at the final dry drawing stage, included some sharper line work.*

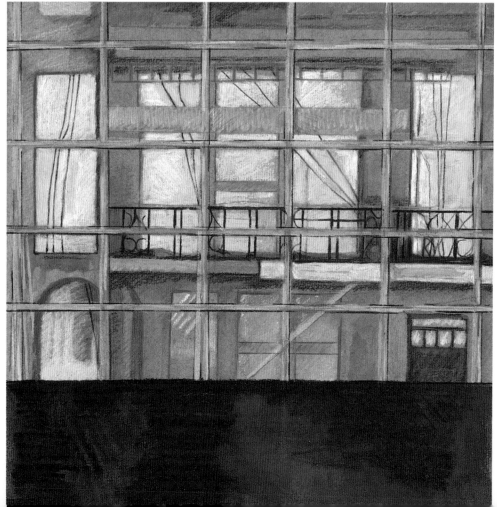

The best technique is to lay in basic shapes with washes, then add dry shading and line drawing to bring up colour accents, pale highlights and solid darks.

Most pencil sets have a white pencil, which comes into its own with this technique. There are also other 'chalky' colours, such as flesh pink, rose pink, pale blue, lilac and sand yellow, for lighter tones. Dark colours are easy to manipulate, though they lack depth in the first layers of wash. Ultramarine, violet, Vandyke brown and even pure black all lack density when diluted with water. Pure hues, such as yellow, red and blue, can be gradually built up to full strength by overlaying dry colour and washes.

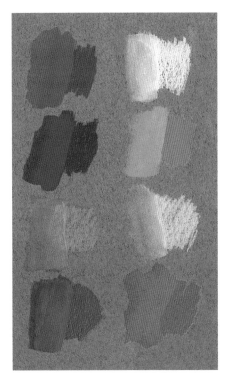

◀ *Yellow, orange or brown papers give more intensity to blues and purples.*

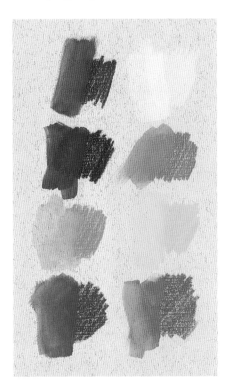

▲ *Dry shading is opaque enough to block out the paper colour, while washed colour is more influenced by the underlying tone.*

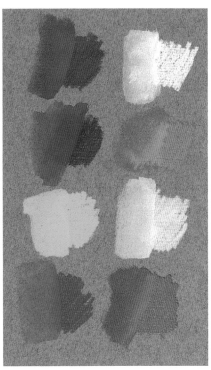

▲ *A blue paper tends to heighten the reds and oranges.*

WATER-SOLUBLE CRAYONS

As well as watercolour pencils, your art supplier may stock water-soluble crayons. These look and feel like ordinary wax crayons but, like the pencils, their colour readily dissolves in water. The major difference between the pencils and crayons is the access you have to the pigment. Because the crayons are relatively soft and not encased in wood, you can apply them much more broadly and boldly. You can also pre-mix crayons more easily than pencils by rubbing them down into water in a palette, or you can develop the spread and colour intensity of washes freely on the paper.

It would seem that crayons have some inherent advantages over pencils. However, crayon is a crude medium compared with pencil, and it is best reserved for larger-scale work. The line qualities are less precise as it is hard to get a really sharp point and the crayon quickly wears down, although you can always combine the two media to take advantage of the pencils' more sensitive touch for line work.

Crayon washes are also less controlled, so you will need to develop a technique more like that of watercolour painting. This may be difficult if you find the freedom of painting techniques intimidating, and so prefer the tighter discipline of drawing.

These paintings, by Brighton-based artist and illustrator Annie Wood, demonstrate how open,

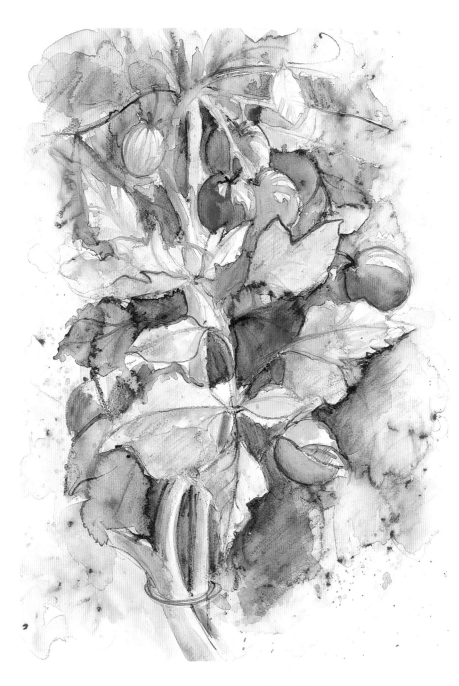

▲ *Annie Wood*
First Tomatoes
50.8 × 35.5 cm (20 × 14 in)

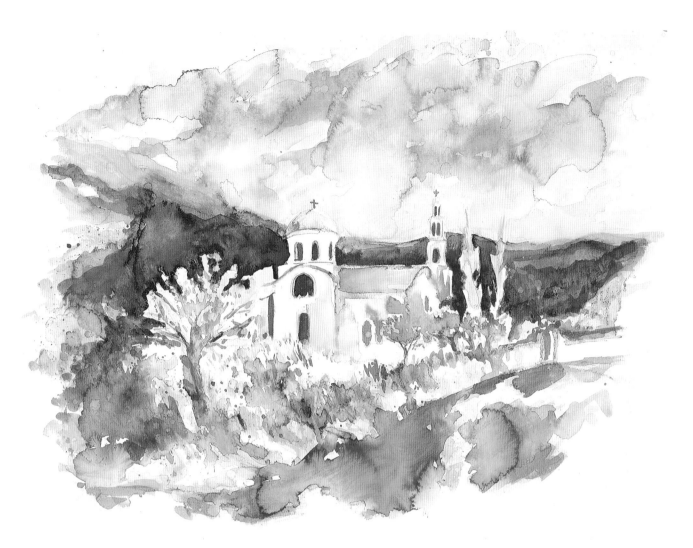

lively watercolour-style images can be made with crayons. She uses a variety of techniques, beginning with dilute, loosely brushed washes and building up to intense hues and colour variegations both by layering the washes and working the crayons direct into the damp surface. She also applies dry-crayon drawing in the final stages to rework the definition of individual shapes, and to adjust the tonal balance with grainy hatching and shading over the dried washes.

The pictures are executed on full sheets of heavy watercolour paper that does not buckle when wetted. Annie Wood exploits interesting textural qualities that occur randomly as the colour is

dissolved – such as a hard-edged finish to the thin washes, where the colour has floated out from the centre and settled into an 'outline'. She also lets colours mingle wet-into-wet, producing beautifully fluid variegations and diffused 'sunbursts' of brilliant hues, which she has applied very effectively to the masses of foliage and blossom in the images seen opposite and above. Another exciting and random effect comes from shaving fragments of colour from the crayon tip into wet washes, which creates a textural mottled or spattered effect.

As with the pencils, the colour range of the crayons includes relatively bright and unsubtle hues. A restricted scheme of

▲ *Annie Wood*
Early Evening – Samos, Greece
76 × 56 cm (30 × 22 in)

harmonious or complementary colours helps to give a picture unity and, as always, the tonal balance is important even when you are working with intense, pure colours. The watercolour technique of leaving areas of clean white paper to show through the strong colours has been used to great advantage in the view of a Greek church (see page 64). You may find it easier to preserve whites when working on a larger scale, because you can still use the crayon or brush quite freely without covering the surface too quickly.

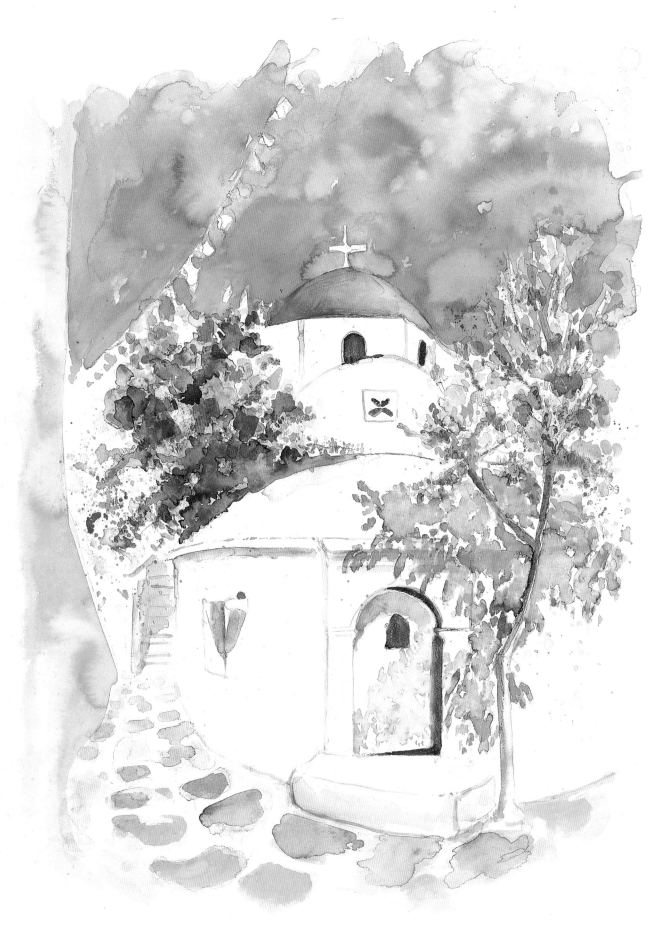

▲ *Annie Wood,* Church Shadows, *76 × 56 cm (30 × 22 in)*